© MOTLEY MAGAZINE
&
© WORM LITERATURE MMXXII

motley mag
volume 1
(issue 1)

First edition: october, 2022

Cover design: João Bresler

© All rights reserved

Printed somewhere in the Earth i hope

ISBN: 978-1-4710-5265-1.

Worm Literature
MMXXII

Motley Mag
VOL.1
thoughts and visuals
selected

Editors And Collaborators Of The MOTLEY MAGAZINE:

EDITOR. João Bresler **@oysterboiwho**

COLLABORATORS.
(in order of appearance, with the first piece being the guide in case of having contributed with multiple pieces)

PAGES 4, 5, 22 & 23_Sylvie **@icuffmyjeans**
PAGE 6 (top)_Rob **@sheriff.bones**
PAGES 7, 16, 87 & 88_Ruby Rose **@slushpuppy.png**
PAGES 18, 19 & 20_Anastasia **@calc1te_ch1roptera**
PAGES 29, 84 & 85_Mark Cheruvallithazhe Philip **@x3n0000**
PAGES 31, 32 & 33_Leah Gould (article) (no contact)
PAGES 36 & 37_Chikilin **@haymalavibra**
PAGES 43, 44, 45, 46 & 47_Plastiboo **@plastiboo**
PAGES 69, 70, 71, 72 & 73_Chico P (no contact)
PAGES 77, 78, 79, 80 & 81_Lur Mitxelena **@kcure.lmii**

All other pieces have been written, drawn, edited, collaged, manipulated or curated by João Bresler.

Some images belong to their respective owners: - "Lo gat qui menge lo rat" was made by Pere Abadal but is currently in the public domain - The Lego minifigure is a registered trademark of Lego® - Guaraná Antarctica belongs to AMBEV® - "The lovers" was made by Reneé Magritte - Robert Pattinson is his own legal person - The xingu stools images were taken from the website www.colecaobei.com.br (Coleção BEÏ) - "Natura morta de l'anguila" was made by Ramon Calsina - The framed flowers are letters in the Fleuron typeface, designed by Mickaël Emile & Yves-Gabriel.

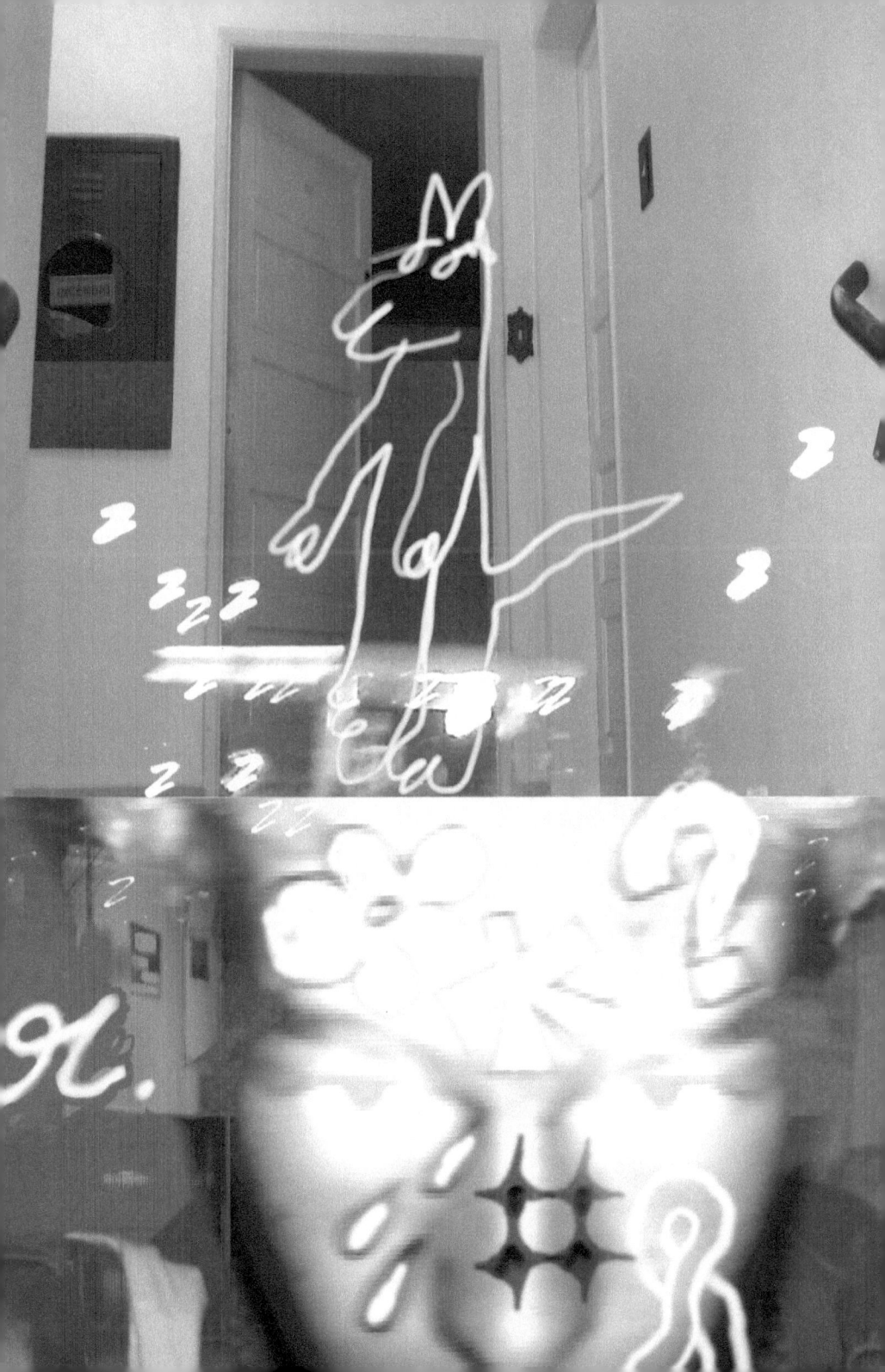

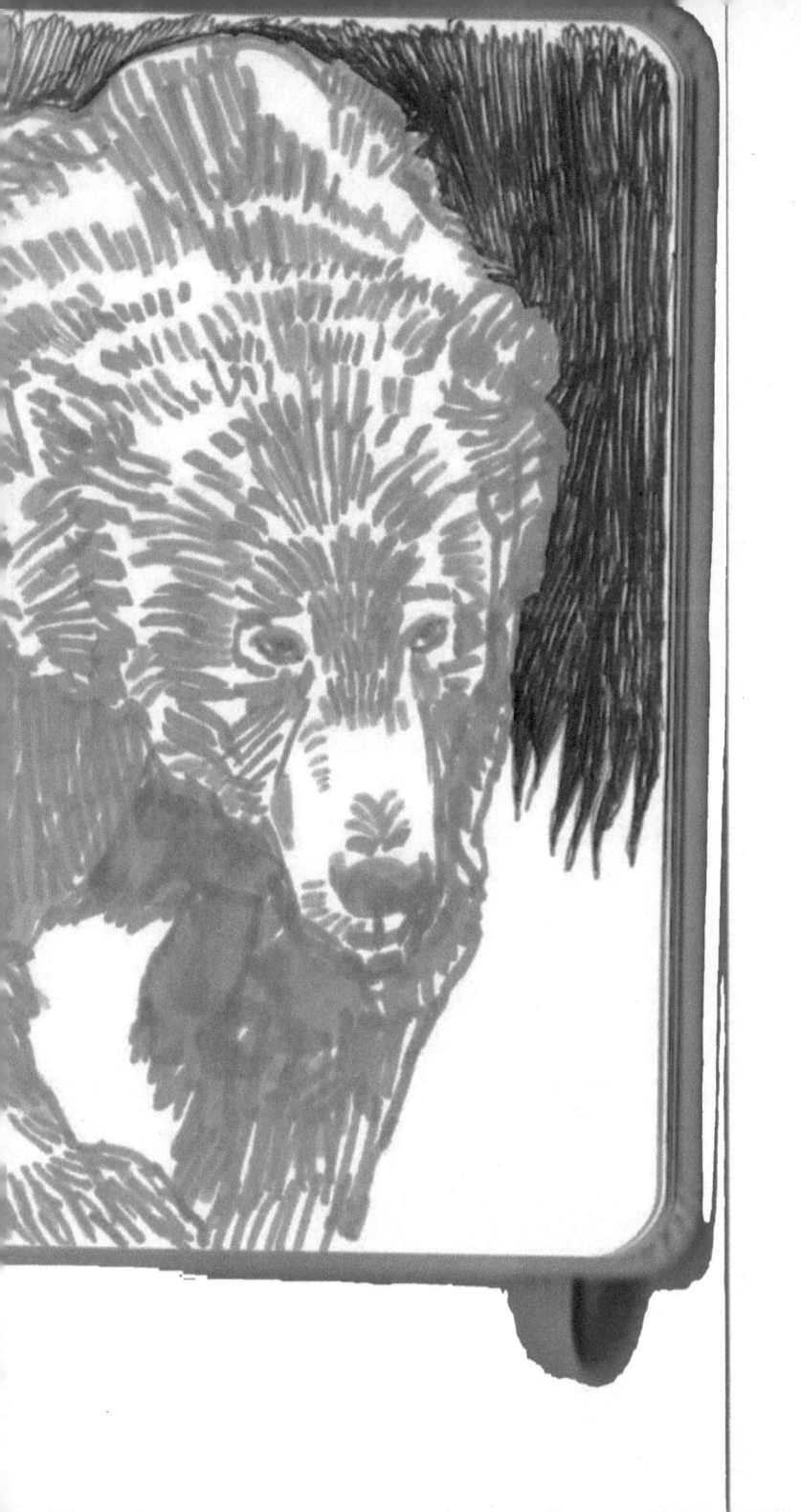

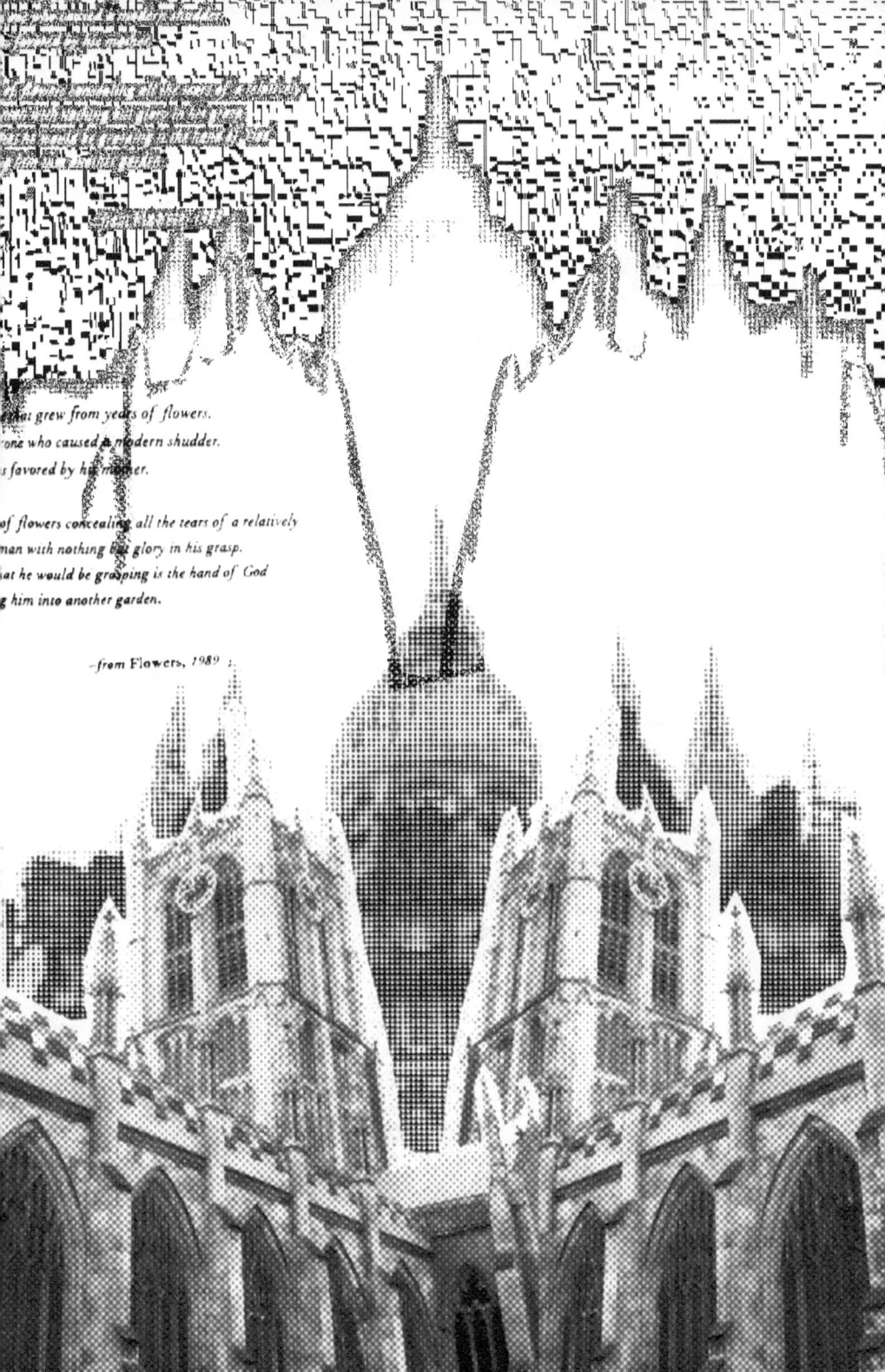

... that grew from years of flowers.
... one who caused a modern shudder.
... favored by his mother.

... of flowers concealing all the tears of a relatively
... man with nothing but glory in his grasp.
... at he would be grasping is the hand of God
... him into another garden.

—from Flowers, 1989

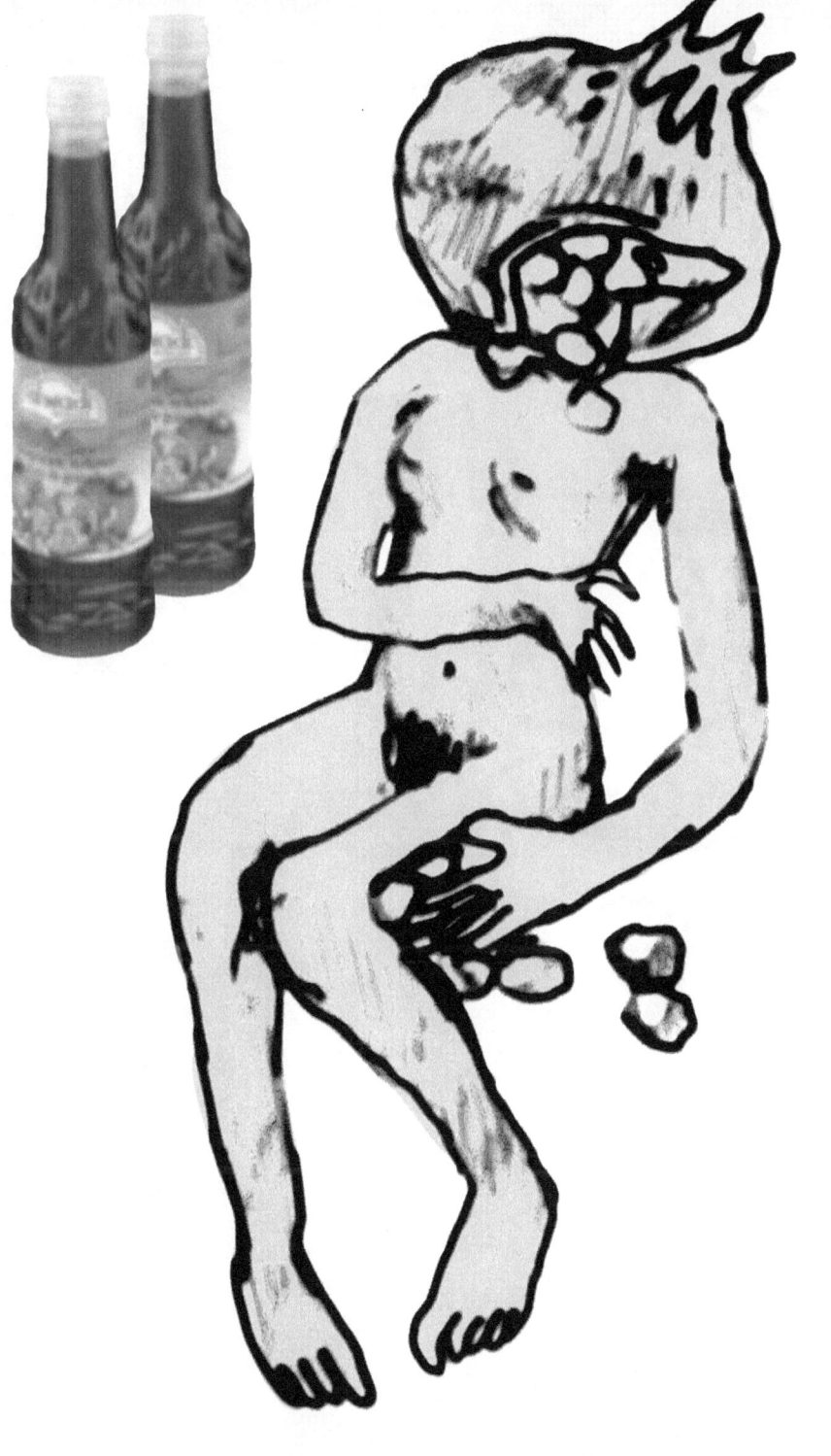

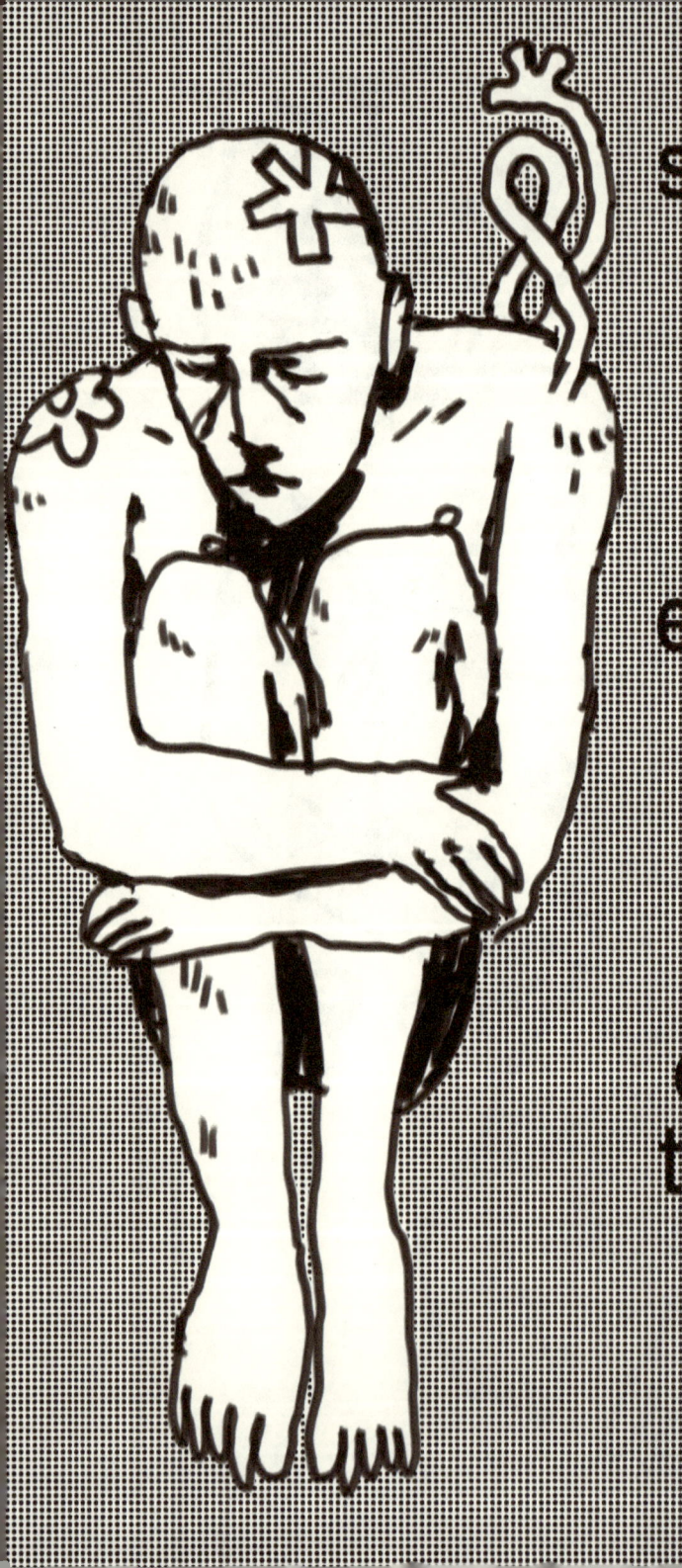

sometimes
i feel like
do a good
job a
being an
ethical and
moral
being

often i fee
the urge to
gatekeep
people

usually it's not people, it's person (1)

lately i've been starting to realise that maybe i should be the one gatekeeped so noone would know me and noone would have to be present in my shitty thoughts

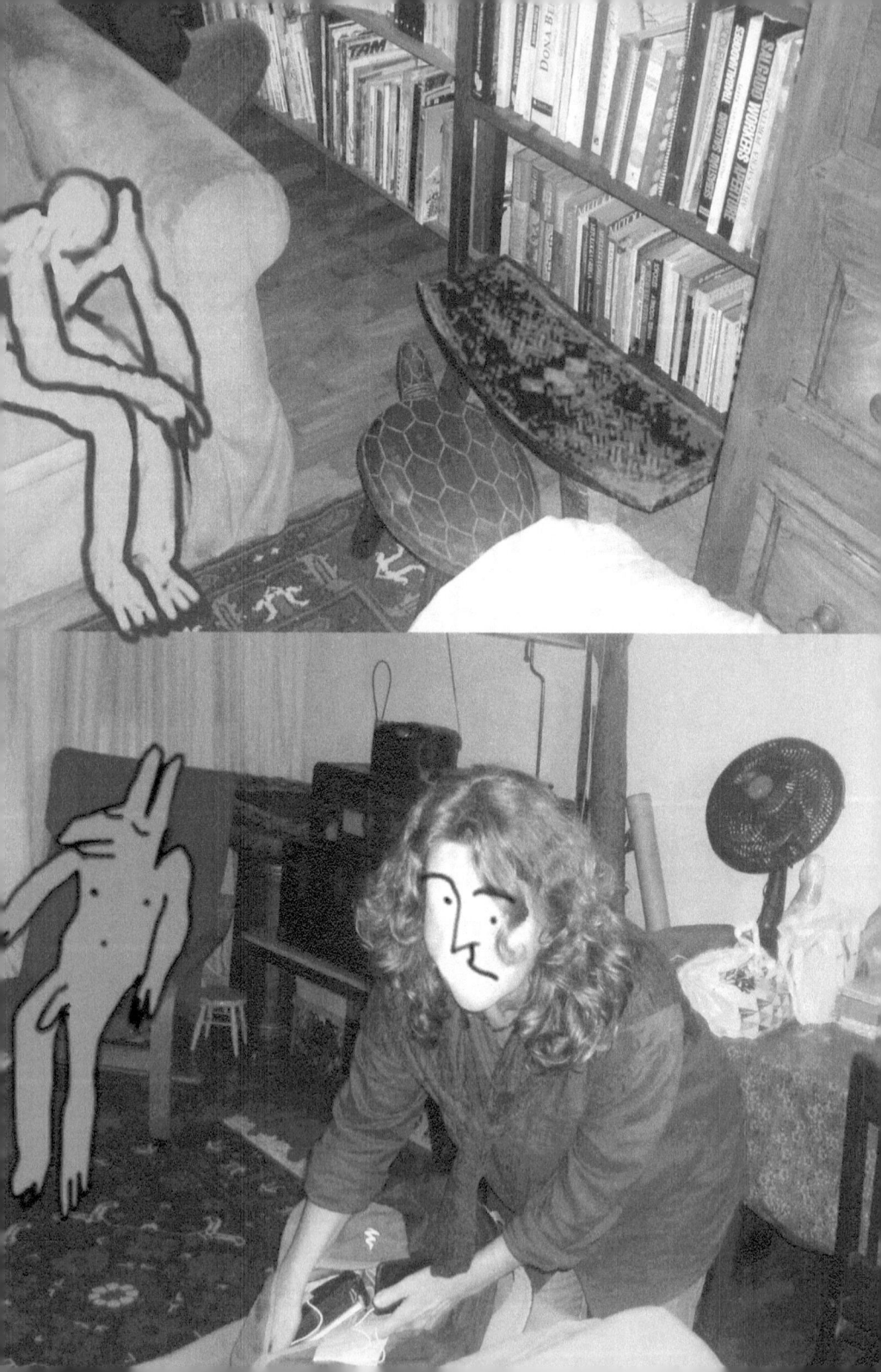

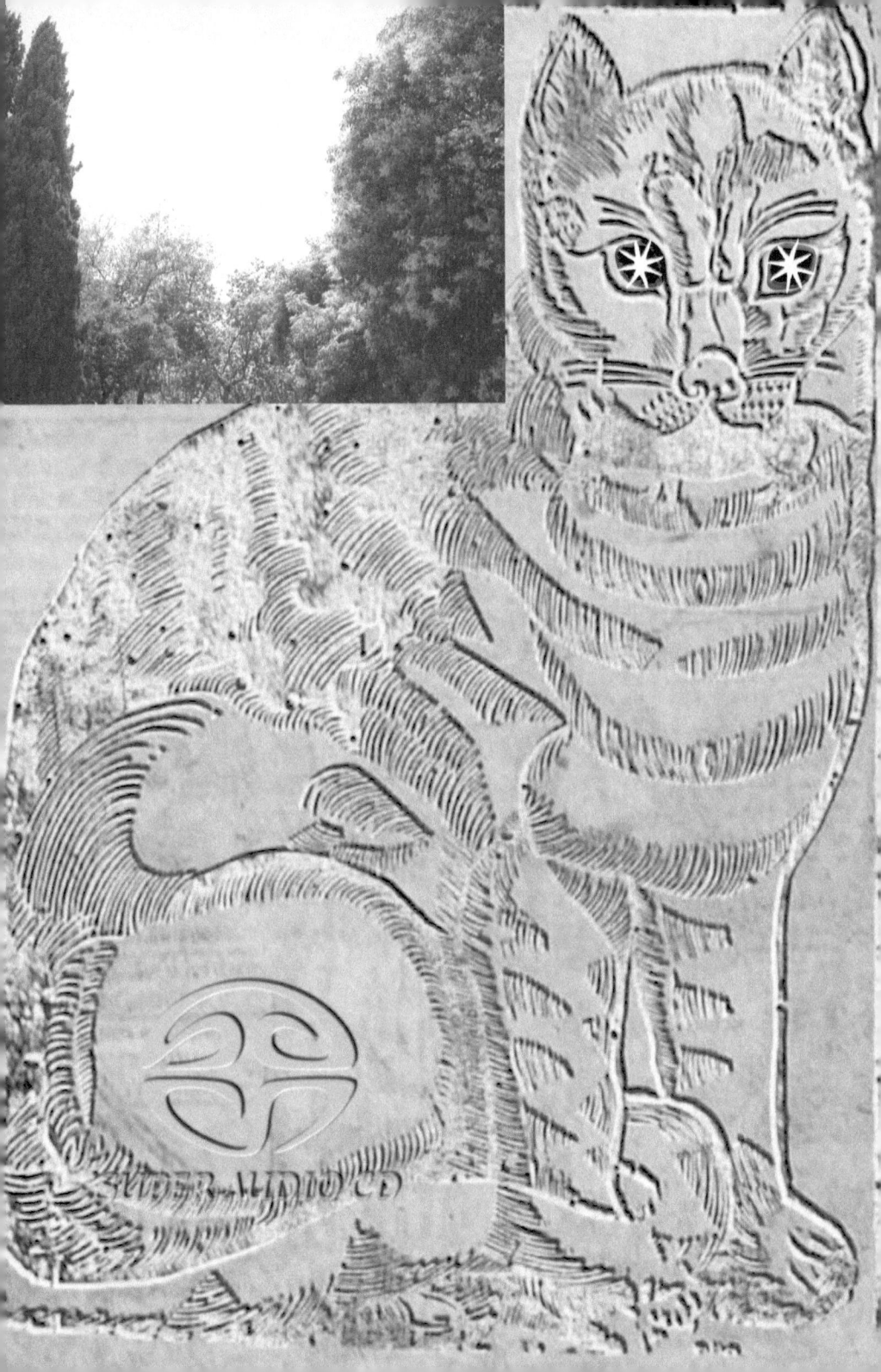

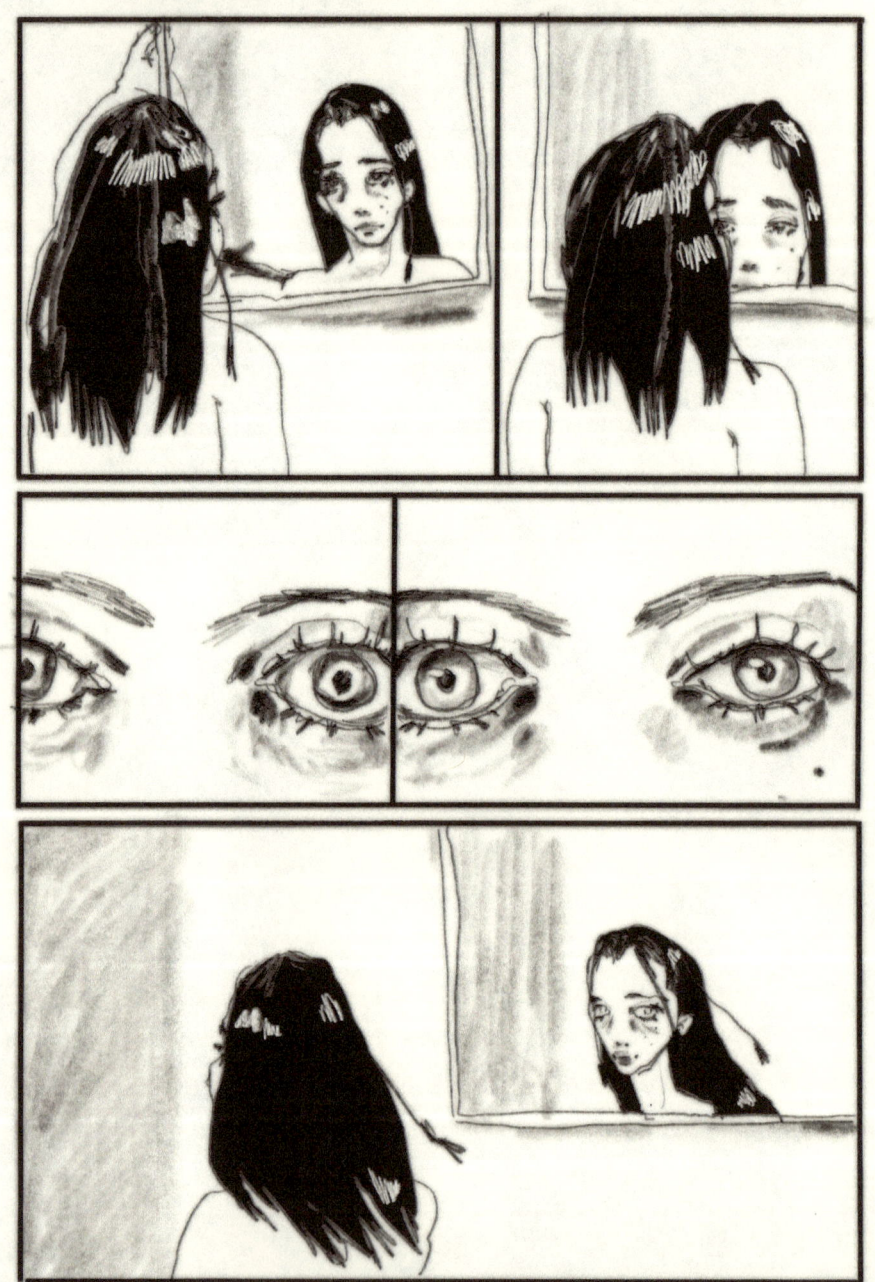

today was the first day
i've ever cried about my parents
I saw a letter he wrote her
years after they'd split
and I was eight
and he was overseas
he was so full of love
and uncertainty
and it bled into my own heart
made me wonder selfishly
for the first time
why they didn't stay in love

i wonder if my effervescent trees below
could ever compare to the sanskrit glow
the rambunctiousness
the pop
of the papery bark when you lick it
the sun here is not a star
but a burning word in the sky
written by the hands of its god
untimely
i ate him whole
without learning the sacred sunshine script
and all i have to offer
are these trees and their candy-filled xylem

can the industrial bar
learn to love the dried alyssum
can he recognise the way in which he stands like fractals
is a crude mimic of her existential ease
can she accept the land he's built on
is made of her very own corpse

scrunched linen
bleached alyssum
bullet-chips in stone pillars
where rusted bars poke through like outstretched fingers
still-soft petals float
abolish gravity
defy the lack of love
and settle in his reddened palms

her teeth are removed
to make way for the emerging form
her first;
a silica statuette
with perfectly angular ears and softened
dark eyes
which should not belong to any mortal
dark eyes
made for watching cement shatter into dust
dark eyes
made for weeping into hardened stone
dark eyes
made only
to be kept shut

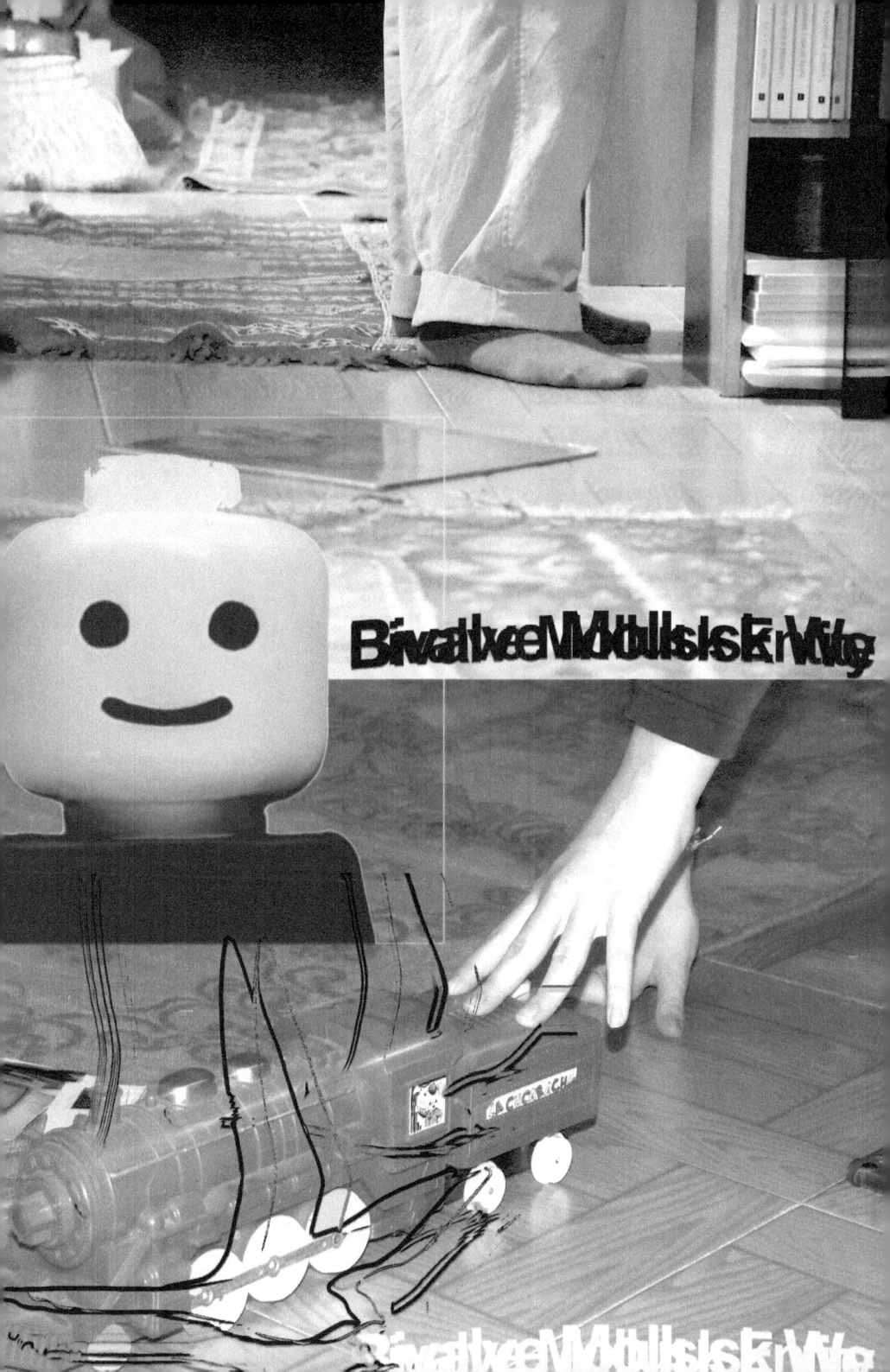

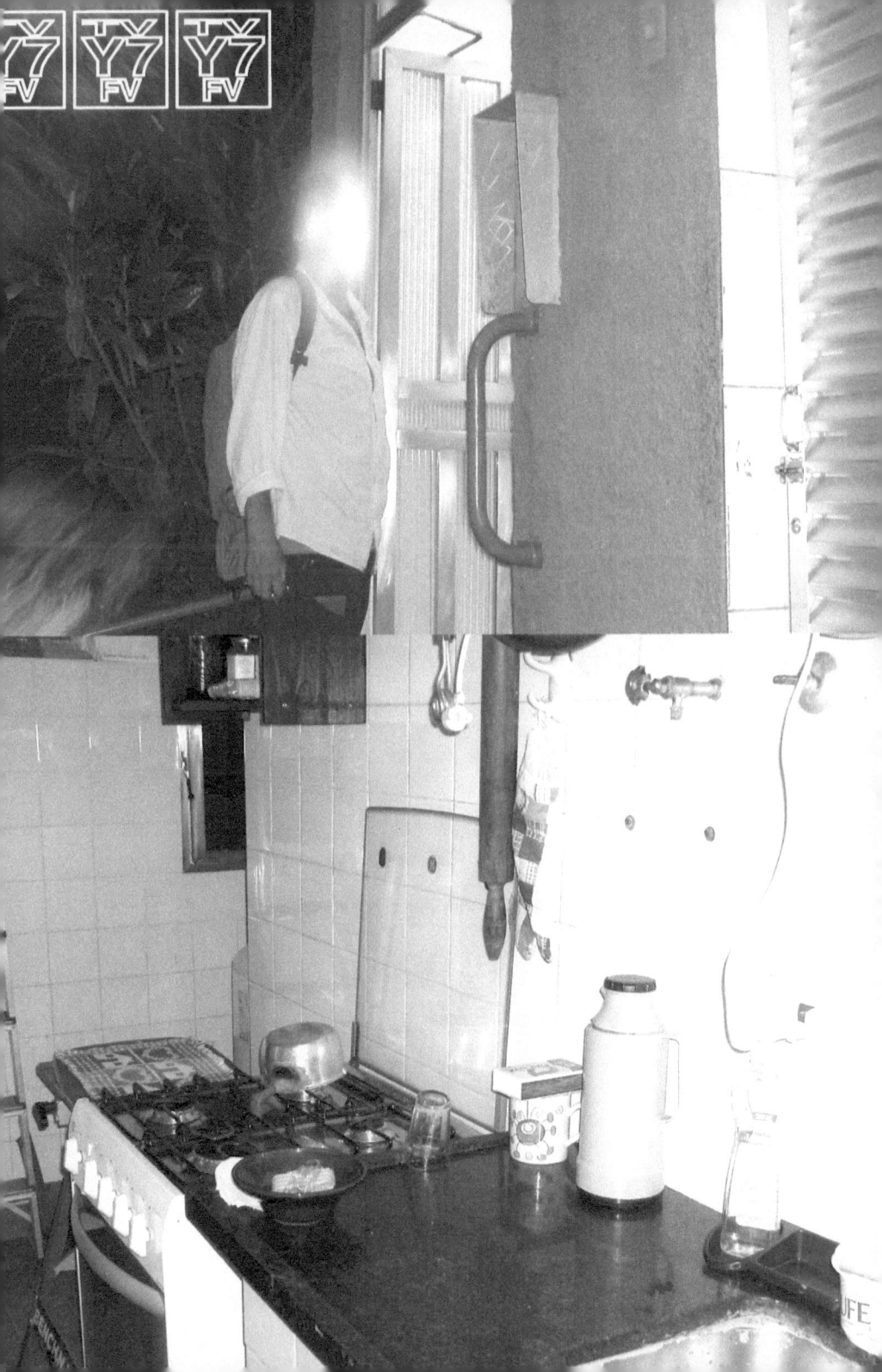

i fear the thought of using
people to forget
i fear not forgetting, and
using said people in vane

puppeteer of strangers'
eyes and bones
and while fearing losing
one, i lose many
but not that one
why can't i forget

lavender still

probably finland

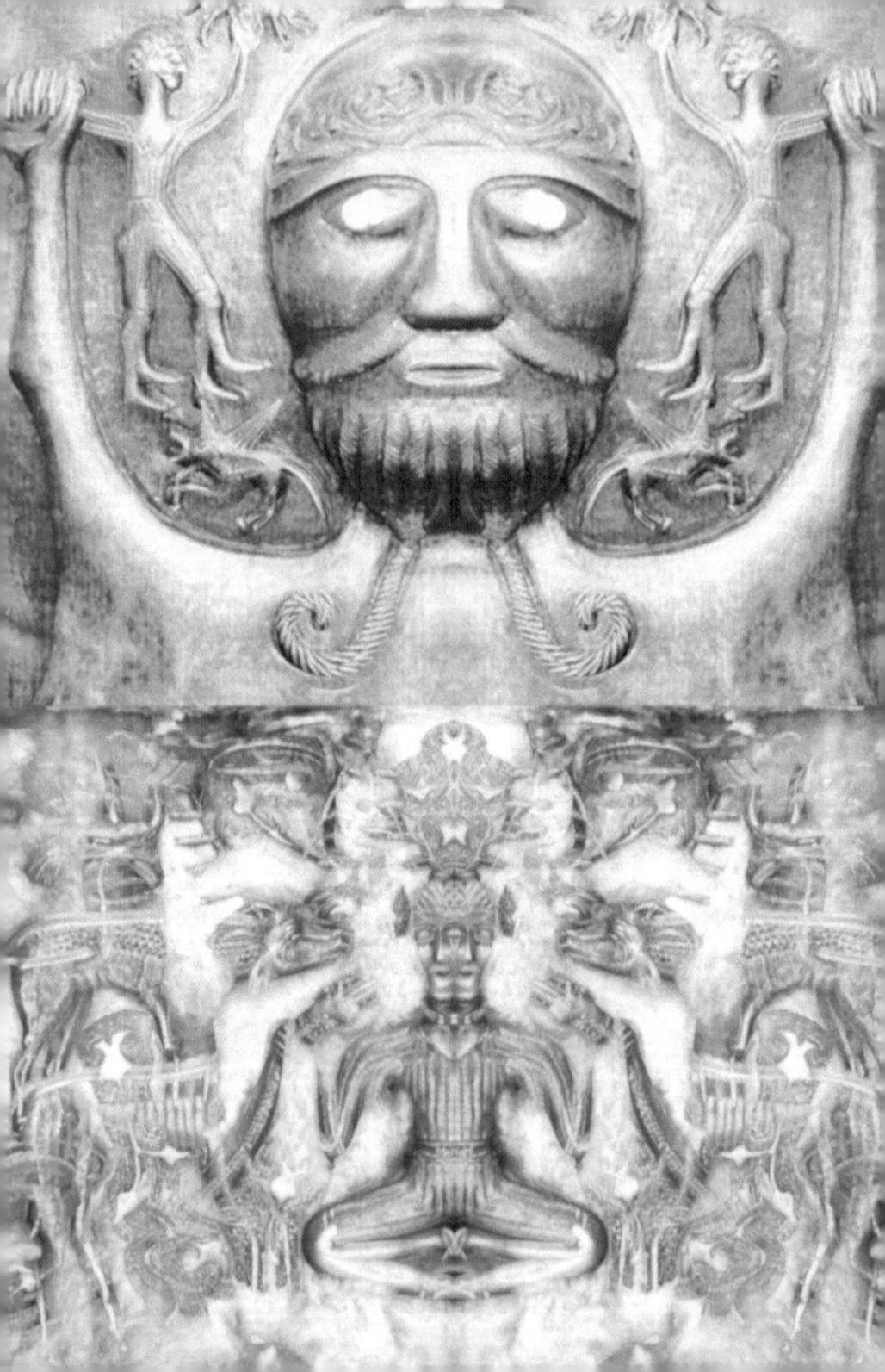

The profanation (desecretion) of the Sand Mummies of Femir

By Leah Gould

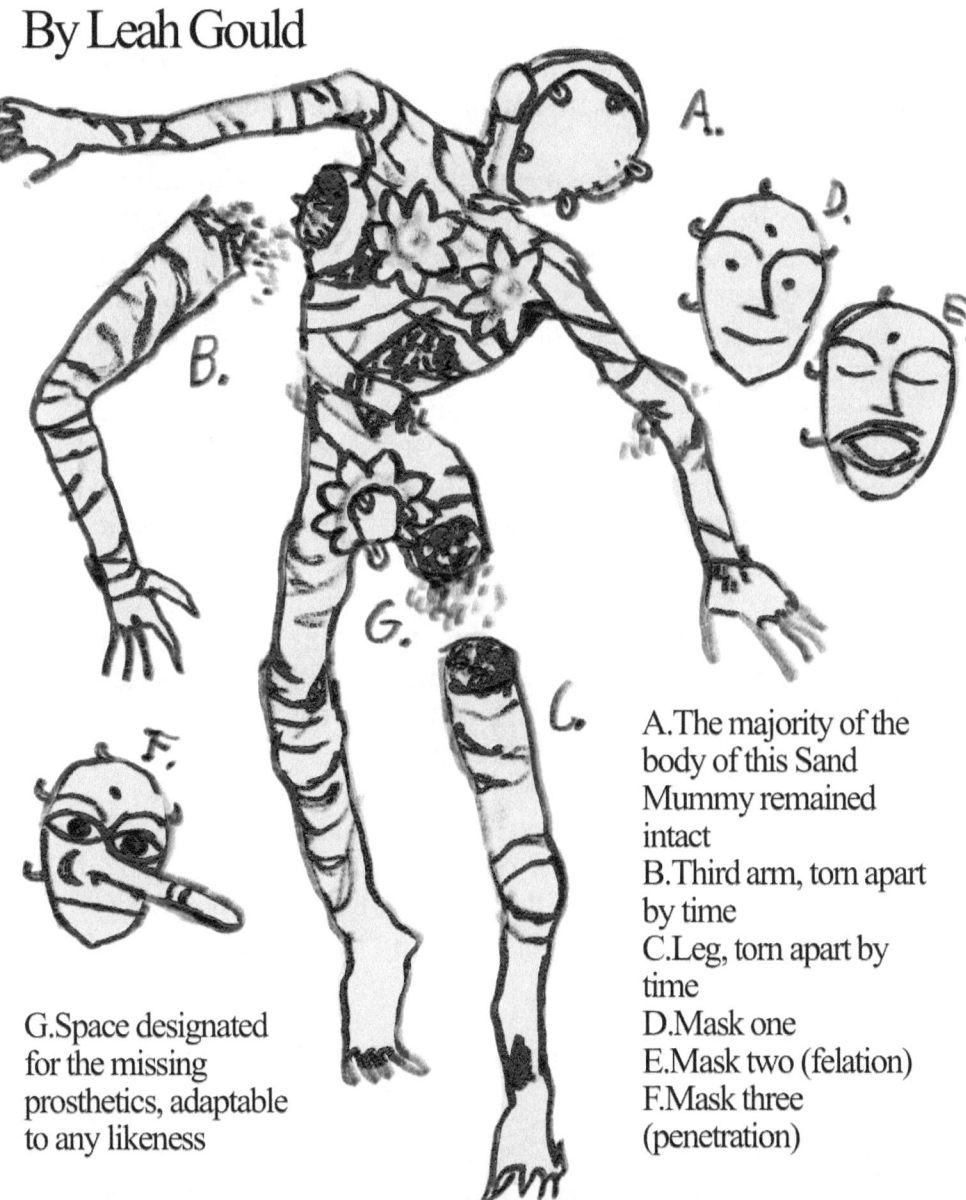

A. The majority of the body of this Sand Mummy remained intact
B. Third arm, torn apart by time
C. Leg, torn apart by time
D. Mask one
E. Mask two (felation)
F. Mask three (penetration)
G. Space designated for the missing prosthetics, adaptable to any likeness

This last Wednesday, the **Femirian Center for Historical Discoveries (FCHD)** was victim to a heart breaking series of incidents.

The large collection of archaic utensils used by the great grandfathers of this peculiar asian "civilization", including the famous group of human-sized sand dolls, faced the attack of dozens of history undergraduates, thirsty for knowledge and something else, who broke into several displays from the **FCHD** and left with a significant amount of archeological pieces.

Among these pieces, fragments from the Sand Mummies of Femir, a collection of 5 dolls, made of sand and cloth, mantaining some visual resemblances to egyptian mummies. Slightly tosque in terms of detail, with the exception of the hands and feet, which were made not with sand but with casts, of human hans and feet, filled with errub, the Femirian rubbery substance similar to latex.
These dolls had attachable faces, nipples and crotch prosthetics. Adjustable for the cerimony attenders likenesses. With several possible combinations the **Sand Mummies** were assembled and used in different types of rituals, weddings, funerals, orgies, transitioning into adulthood...
And as it is known the Femirians had settled away from any contact with other civilizations, thus not being restricted to the more common gender and sexuality norms. Femir was a land of free people, who could enjoy the comfort of the Sand Mummies indifferent from their gender and preferences.

The sexual prosthetics had been made and adapted for their best adaptability to suit all kinds of Femerians. And the group of students were fully aware of this, for what they gave more weight to getting the items than being guided by their morale and work ethics.

The identities of the burglars remain unknown. Their intentions, quite the opposite.

SOURCE:

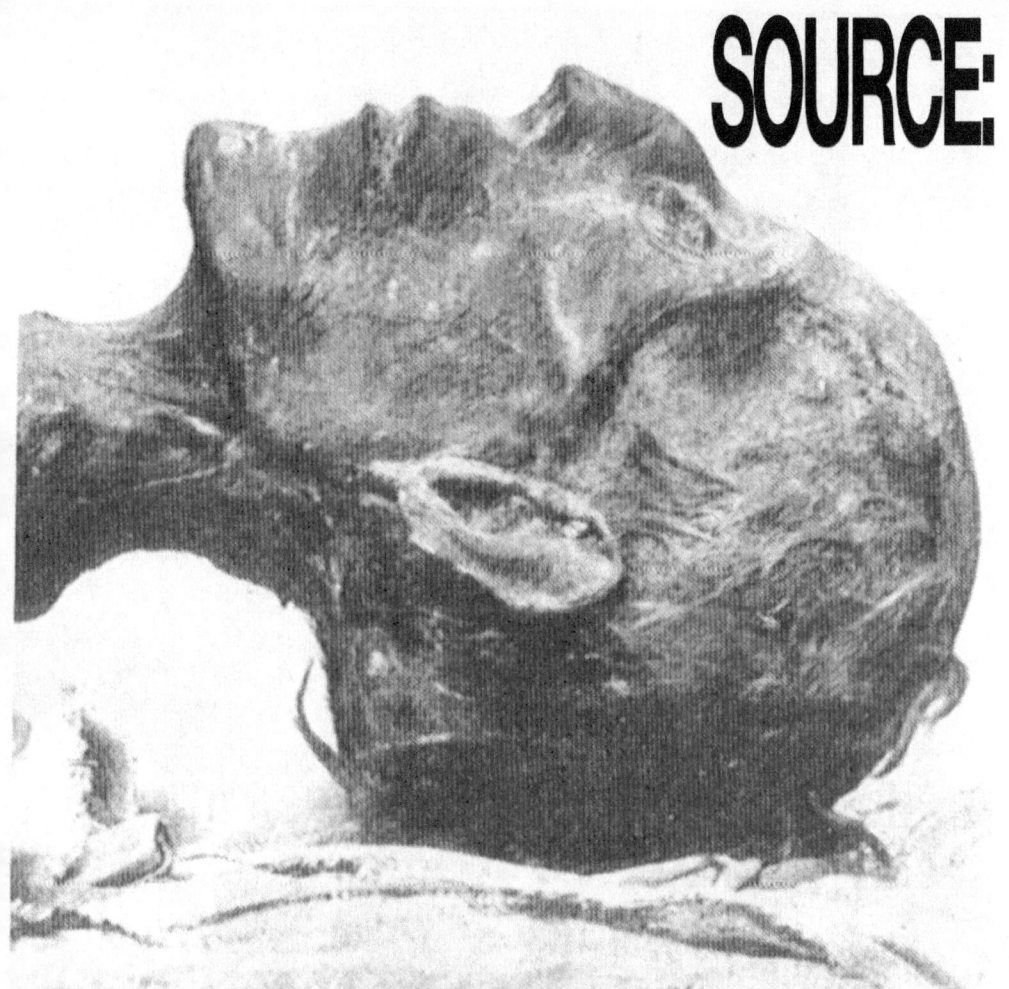

Con el saqueo y profanación de las tumbas egipcias, cosa que se produjo ya desde el comienzo, muchas de las momias fueron desenterradas y se conservaron cubiertas de arena que por su sequedad las protegía de la descomposición. (Fragmento de la momia de Ramsés II.)

人間のナレーター

犬の話

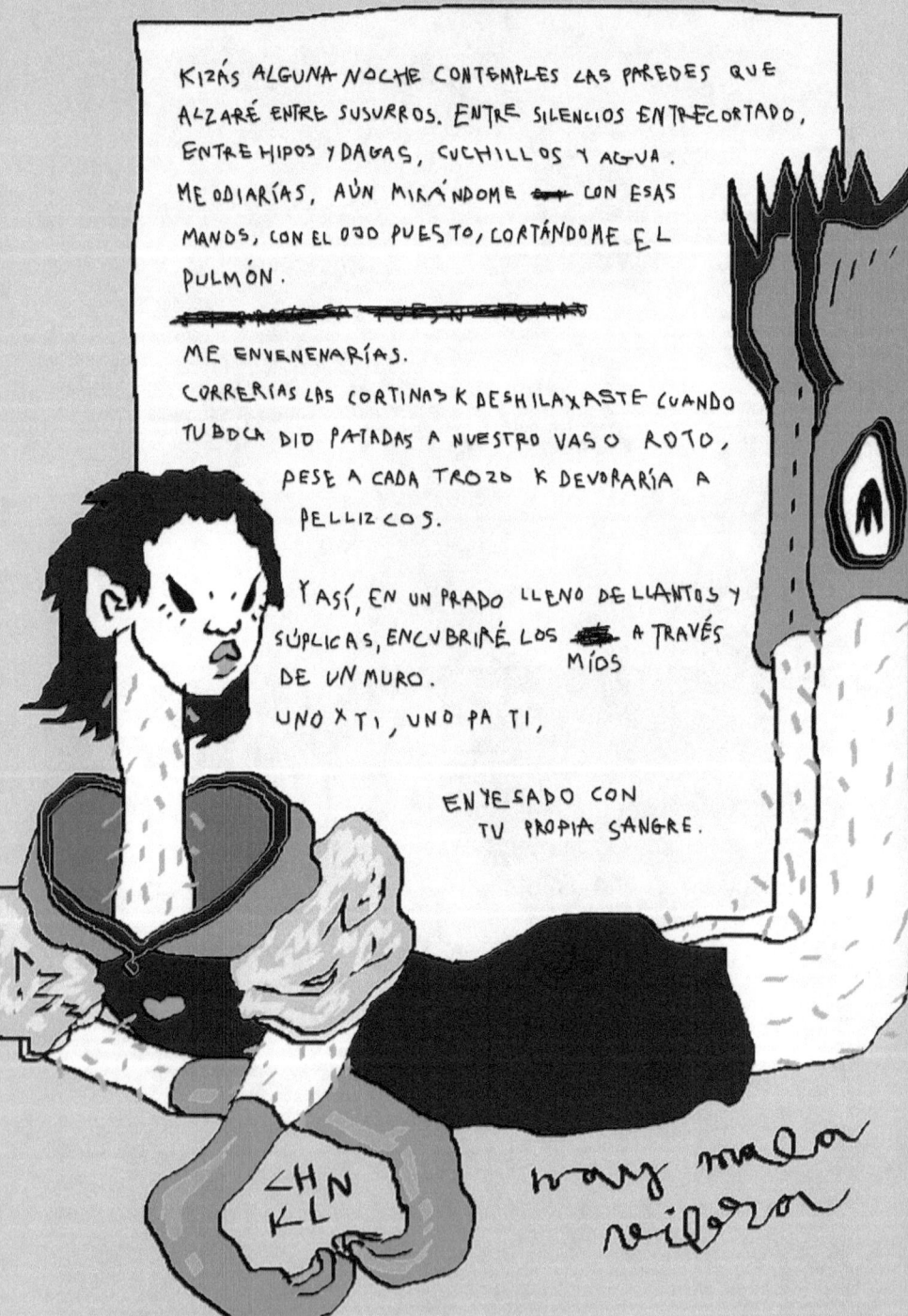

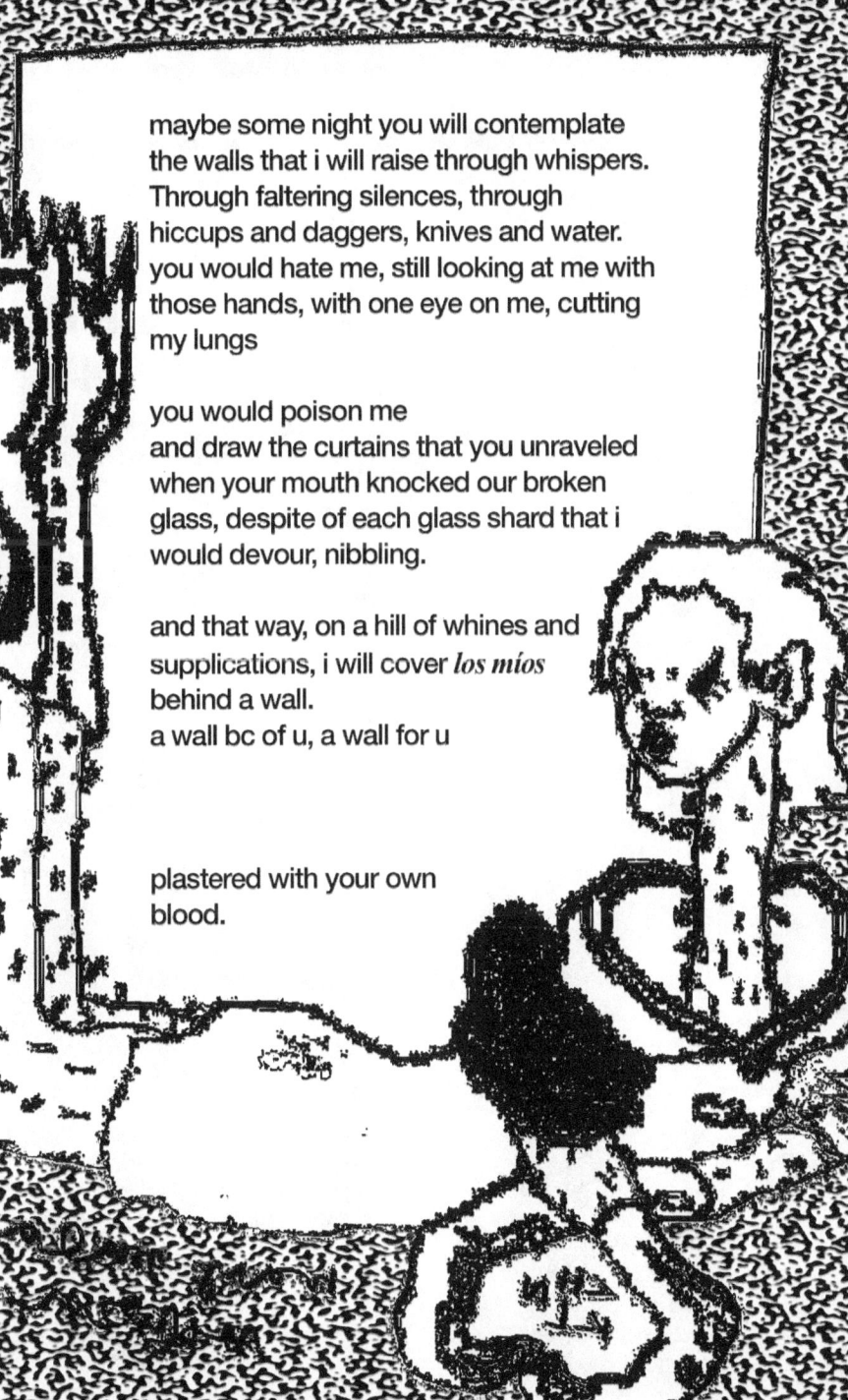

maybe some night you will contemplate
the walls that i will raise through whispers.
Through faltering silences, through
hiccups and daggers, knives and water.
you would hate me, still looking at me with
those hands, with one eye on me, cutting
my lungs

you would poison me
and draw the curtains that you unraveled
when your mouth knocked our broken
glass, despite of each glass shard that i
would devour, nibbling.

and that way, on a hill of whines and
supplications, i will cover *los míos*
behind a wall.
a wall bc of u, a wall for u

plastered with your own
blood.

the thought worm

Separation Labels Go Here

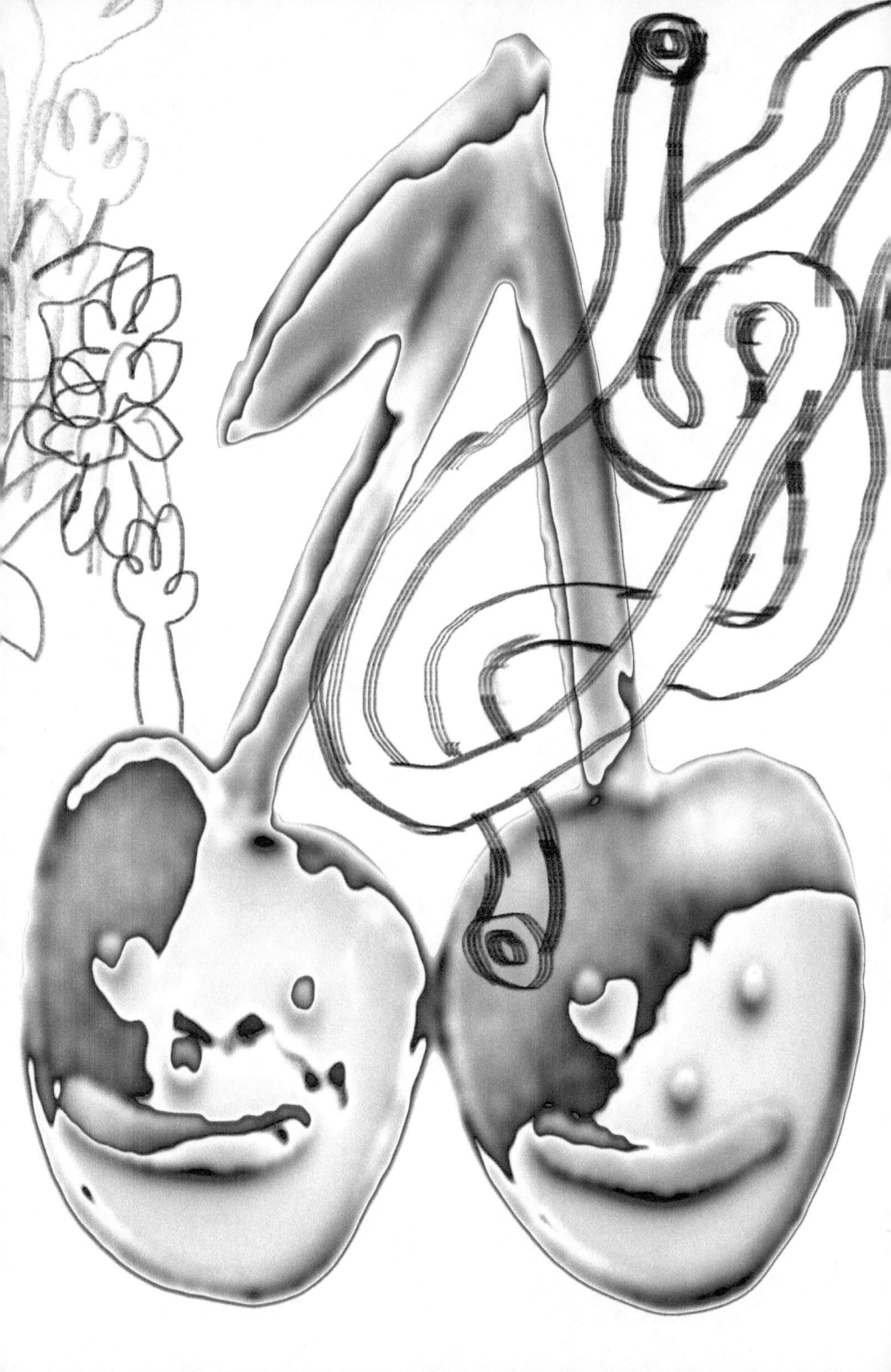

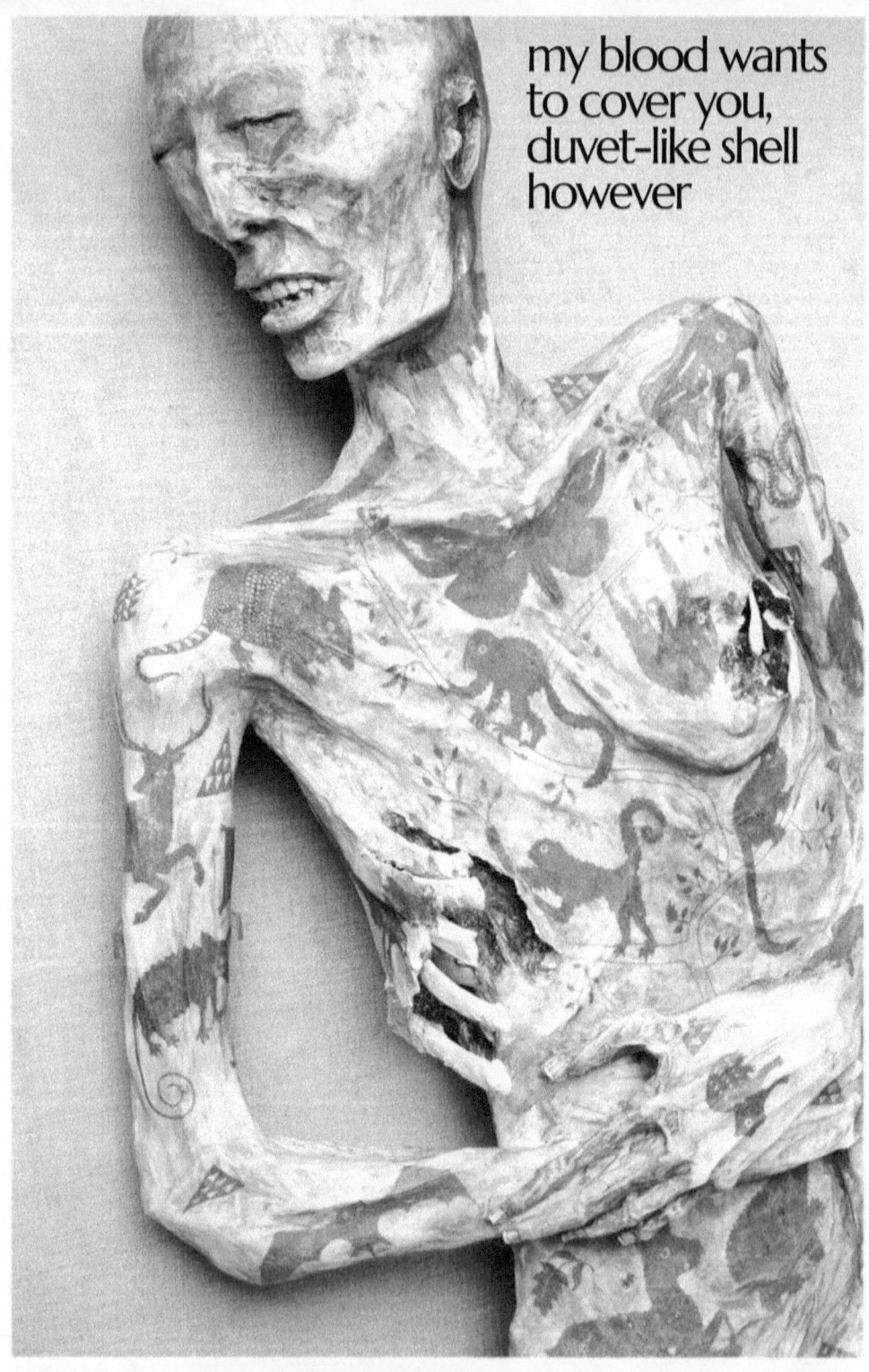

however my thought worm,
the one that considers a bit too much
says you are not to be covered in a blood blanket
you are not to eat my heart,
to have a fridge and a bed and a router
which are the things that make a house,
my thought worm says my heart is no home for you

the blood pumps,
i hear it when we're laying on the couch
my head on your chest
boom boom my head subtly vibrates
in sincrony with your ribcage
and my blood likes it
my thought worm is confused
maybe it likes it

if it was my blood's responsibility
to let people live in my pumping red valve
a door would have to be installed
oh but my thought worm can't handle two visitors
can only share blood and sweat with one
i want more than only one to live in my pumping red valve
it doesn't need a door
but it doesn't need a lock either

i like it when i feel the pumping blood vibrating your ribcage
but i also like the tiny golden hairs that scatter the sun
and i also like the eyes that live far far away

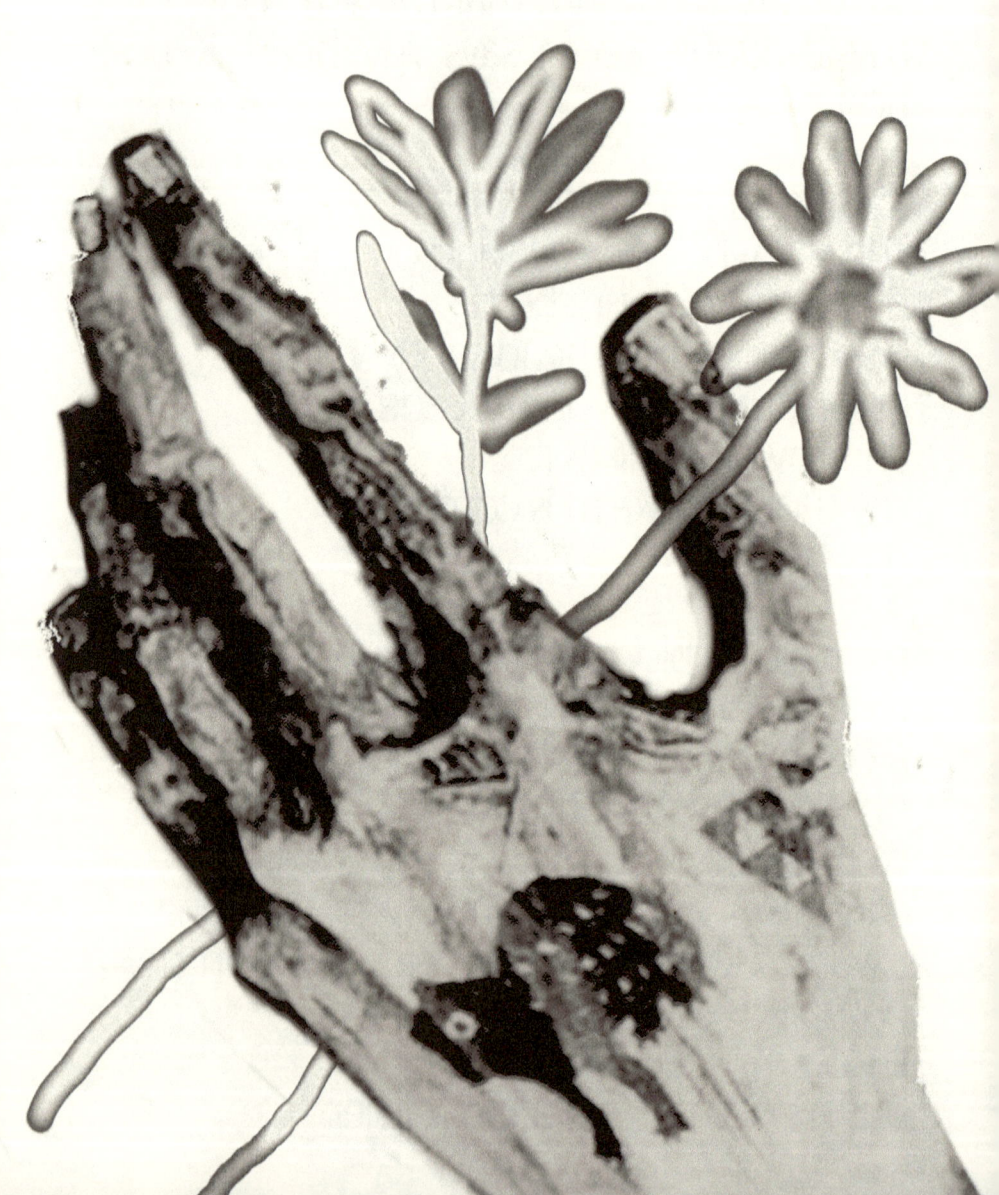

Roadkill Runaboy

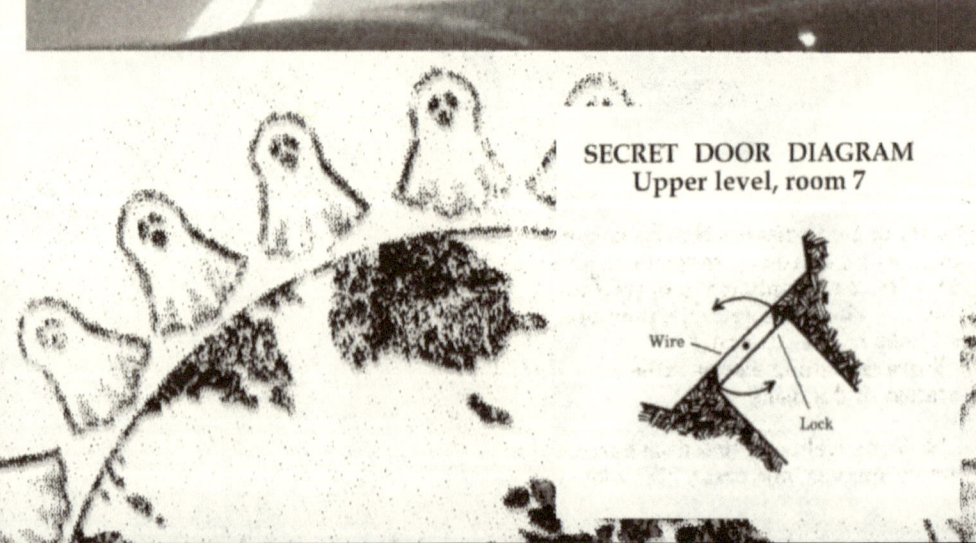

SECRET DOOR DIAGRAM
Upper level, room 7

Wire
Lock

Ex. 17. [SOMODO]

Find the doll

egg

OYSTERA

ACTUS

Fig.1
Guaraná soda can

Fig.2
Guaraná fruit

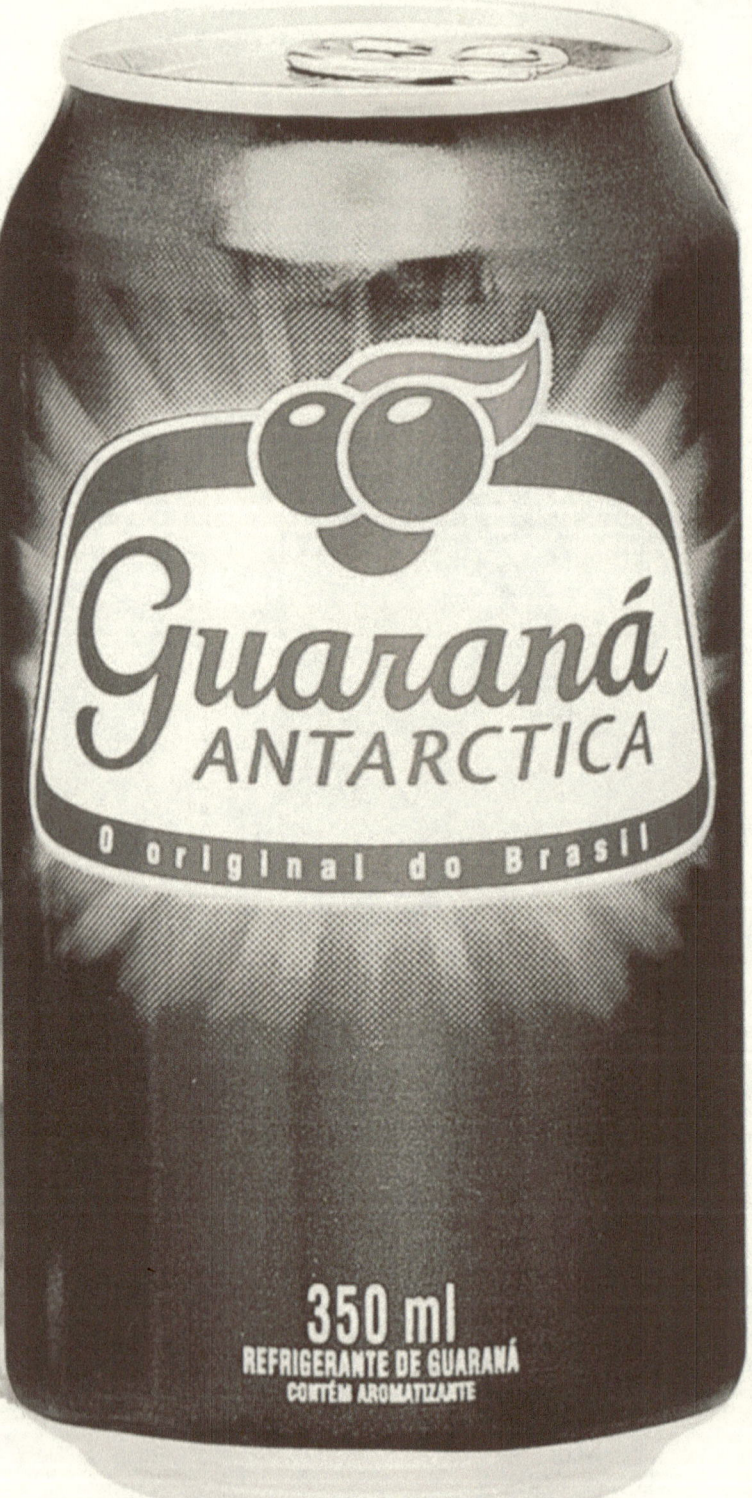

Guaraná plays an important role in Tupi and Guarani culture. According to a myth attributed to the Sateré-Maué tribe, guaraná's domestication originated with a deity (Jurupari) killing a beloved village child (Aguiry). To console the villagers, a more benevolent god (Tupã) plucked the left eye from the child and planted it in the forest, resulting in the wild variety of guaraná. The god then plucked the right eye from the child and planted it in the village, giving rise to domesticated guarana.

Reference:

Beck, H. T. (2004). "10 Caffeine, Alcohol, and Sweeteners". In Ghillean Prance; Mark Nesbitt (eds.). Cultural History of Plants. New York: Routledge. p. 179. ISBN 978-0-415-92746-8.

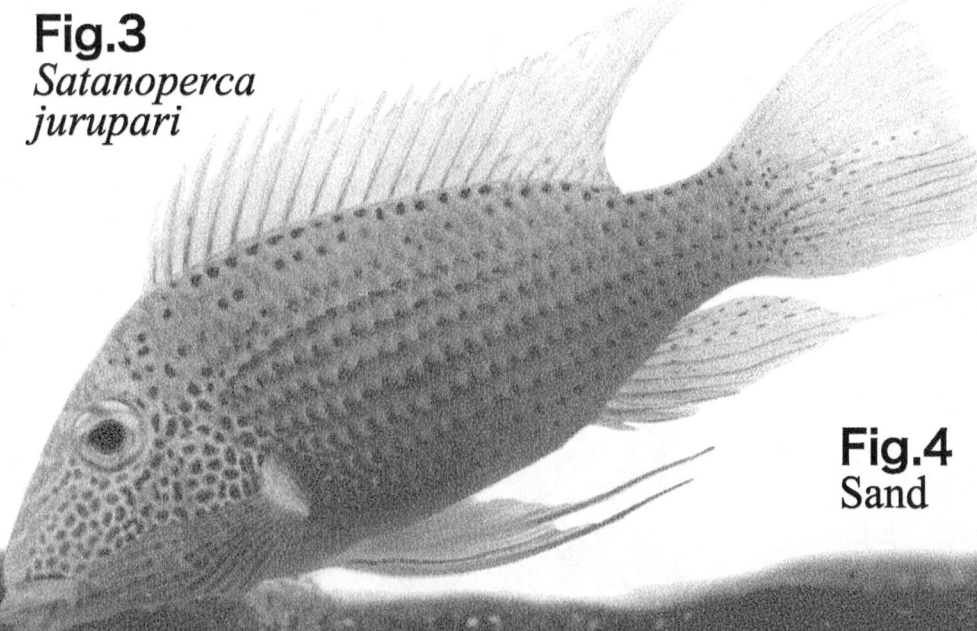

Fig.3
Satanoperca jurupari

Fig.4
Sand

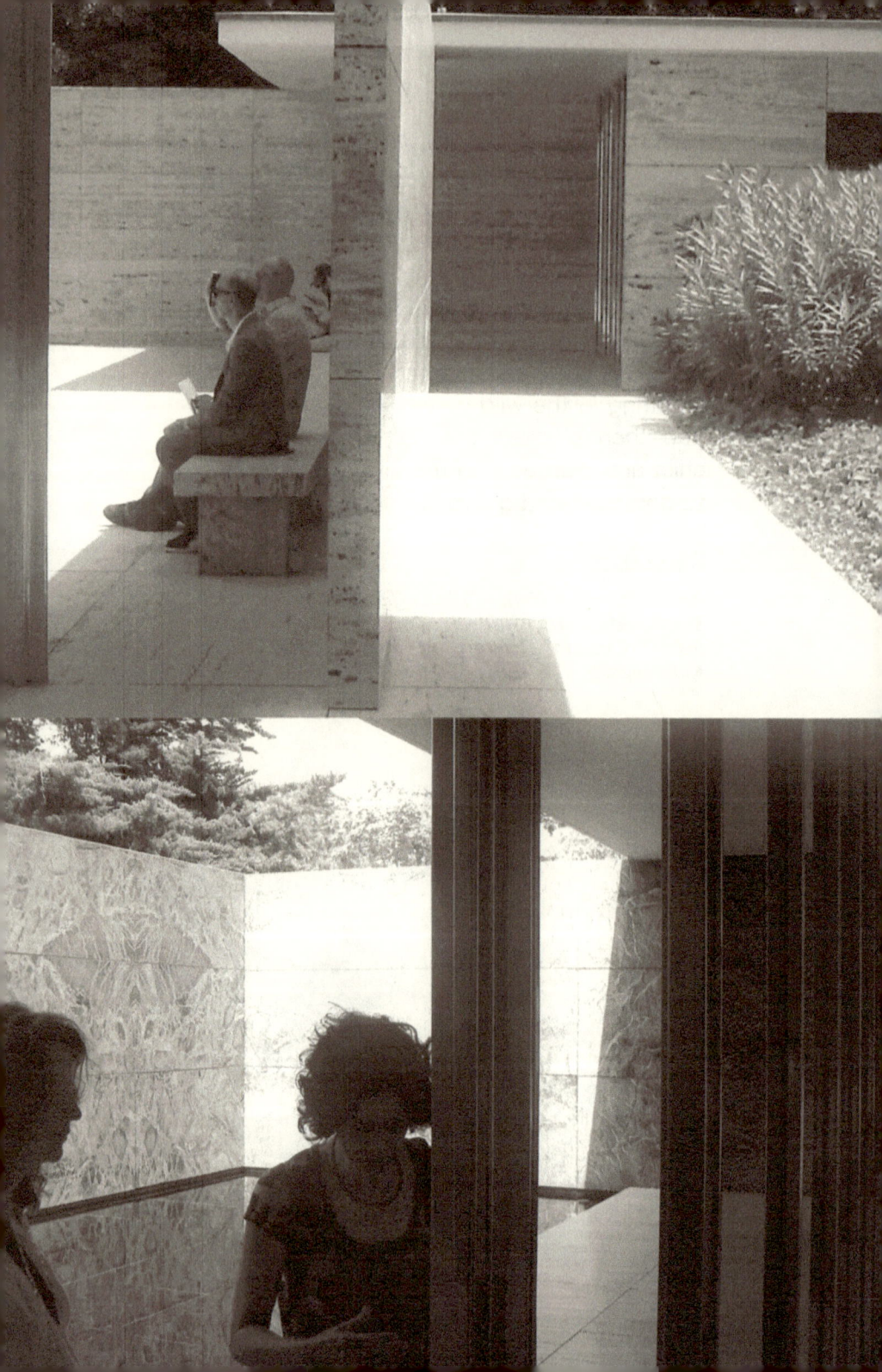

RÜG5

A COLLECTION OF SEMIGENERATIVE DIGITAL TAPESTRY

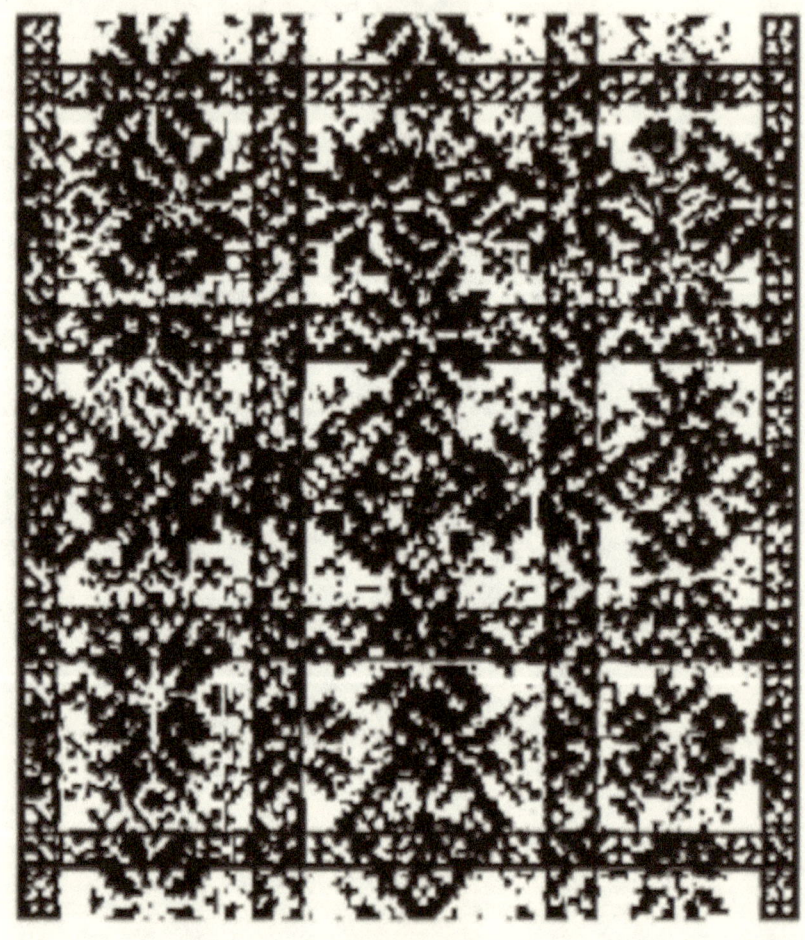

No.1

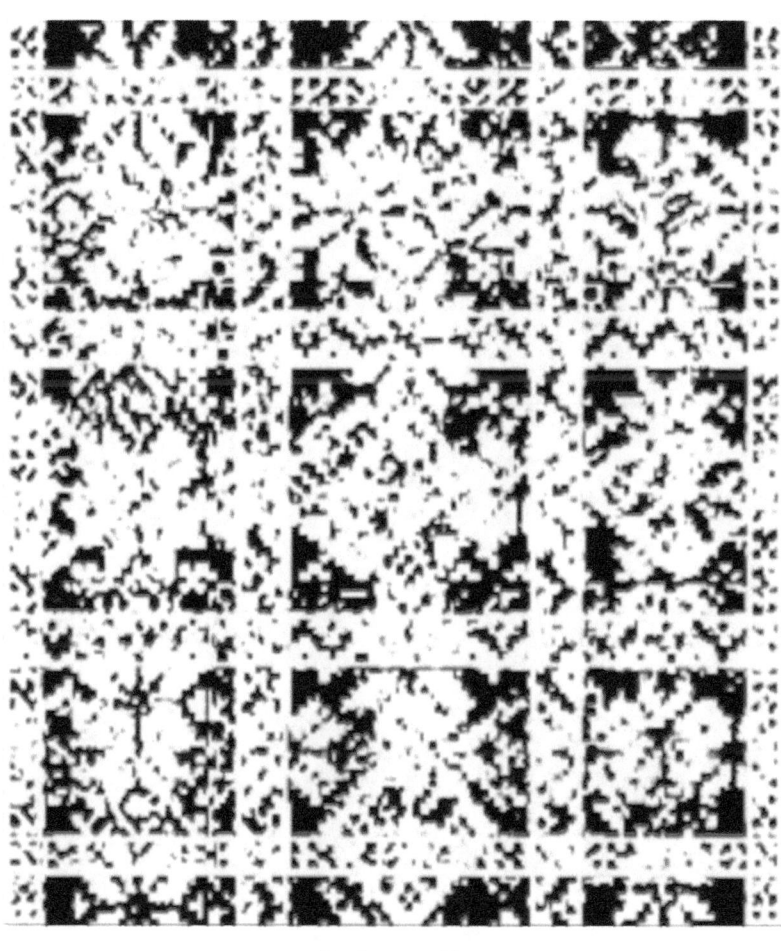

No.2

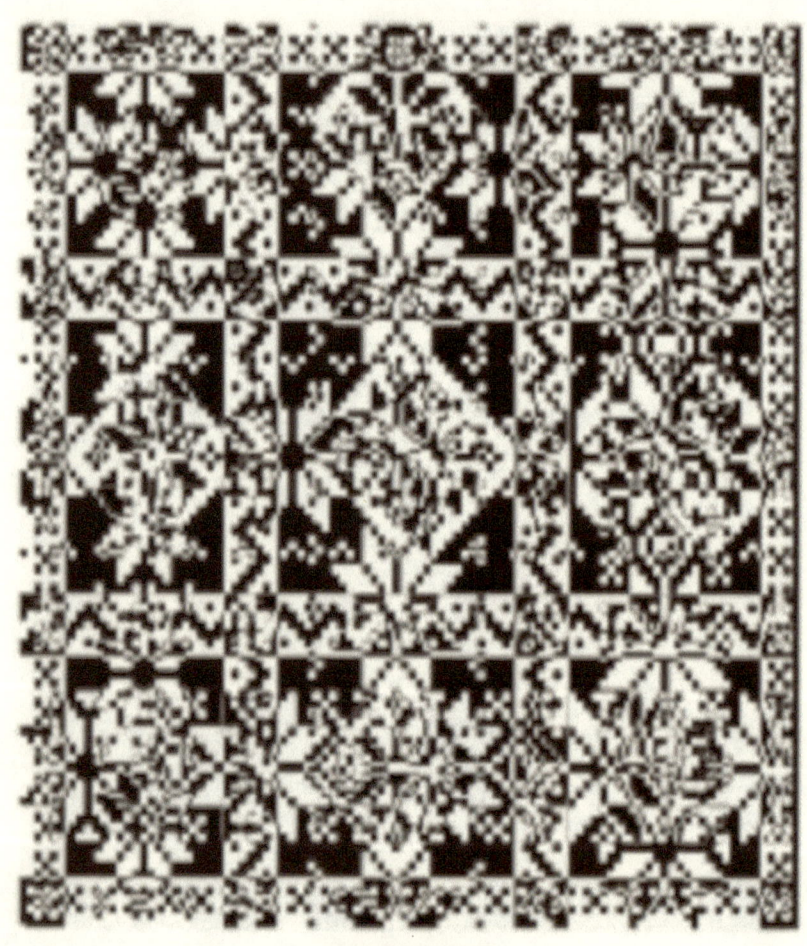

No.3

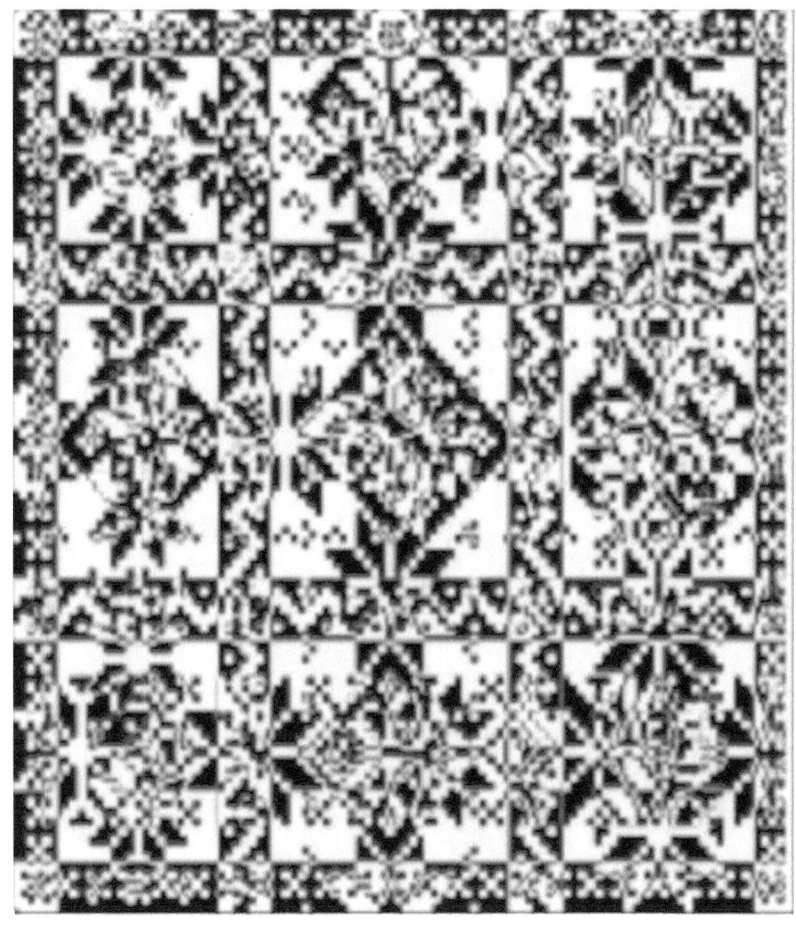

No.4

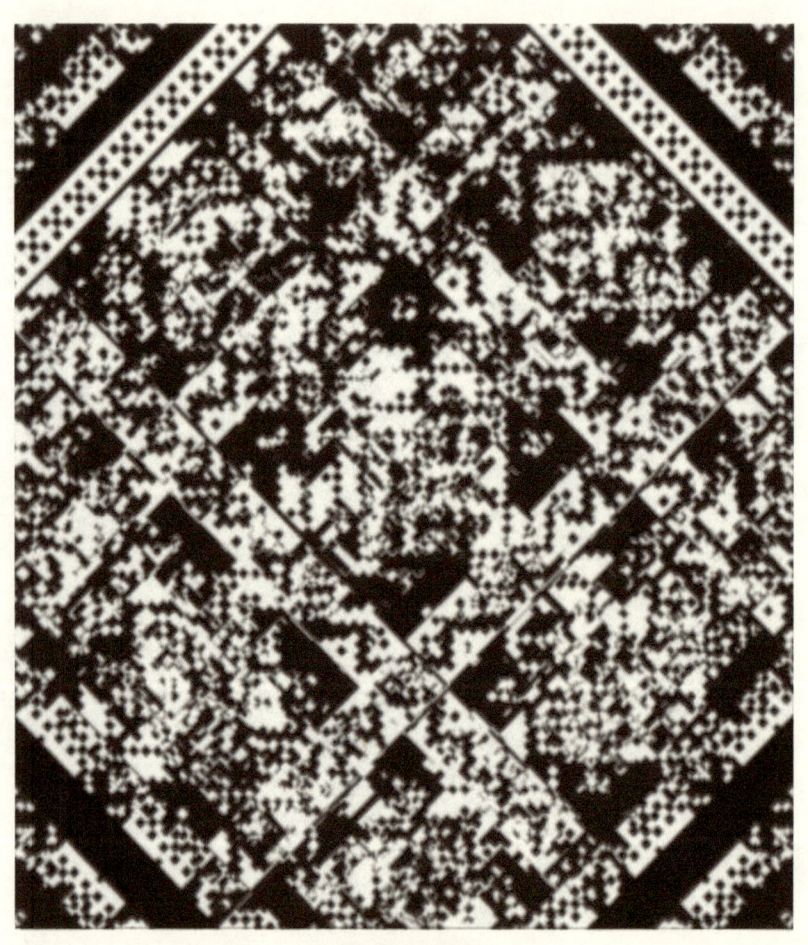

No.5

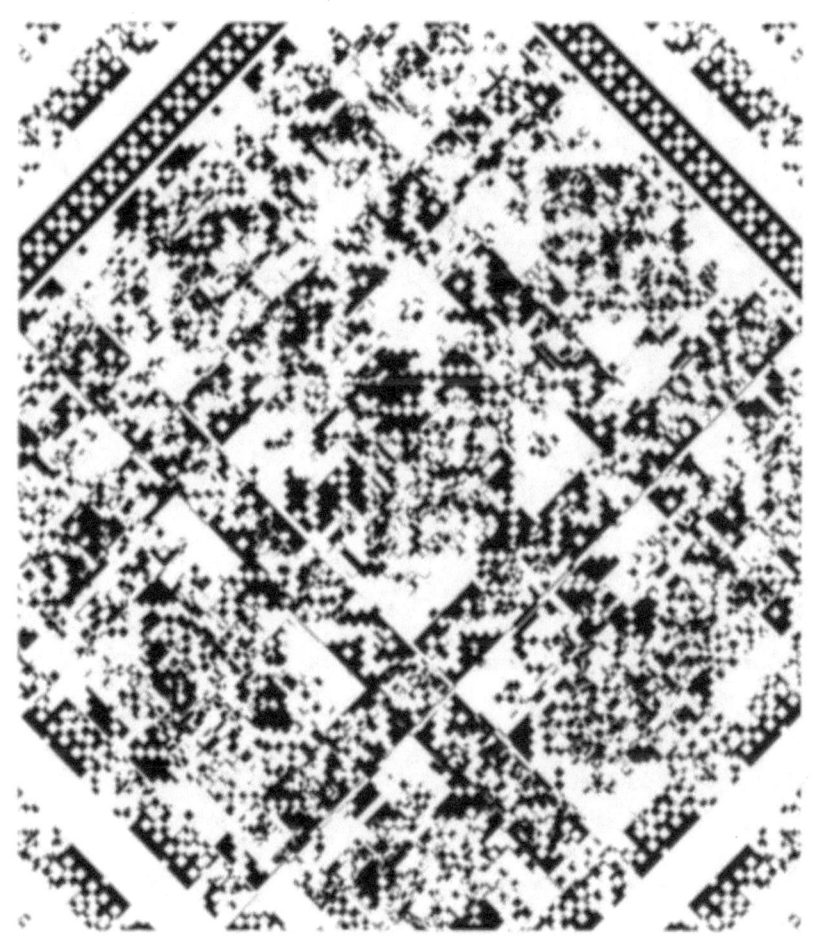

No.6

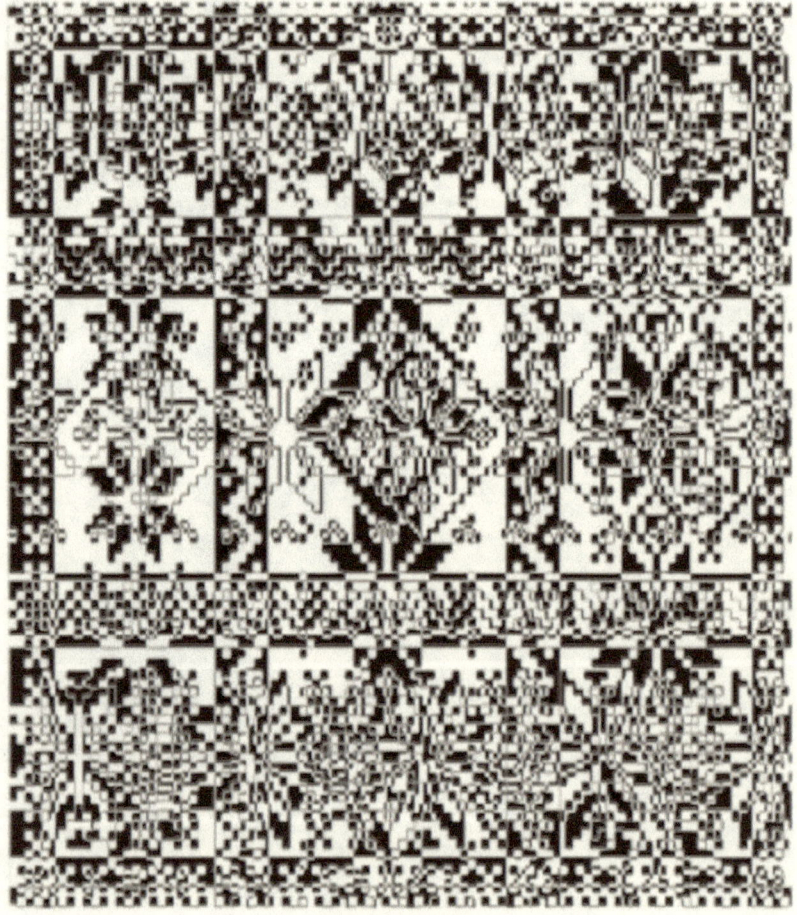

No. 7

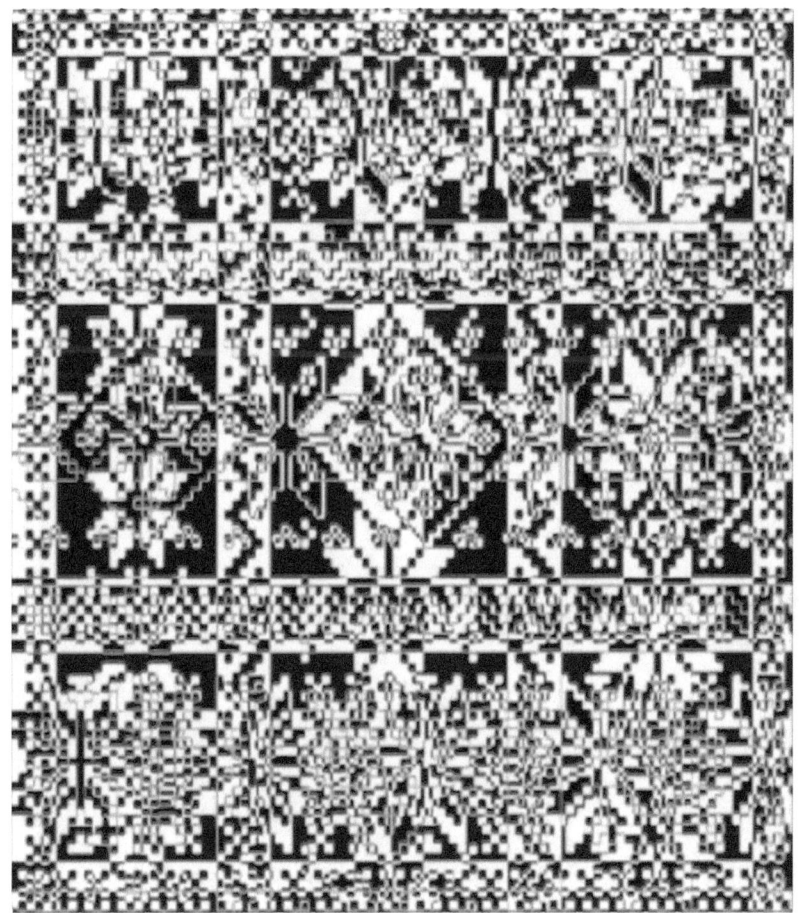

No.8

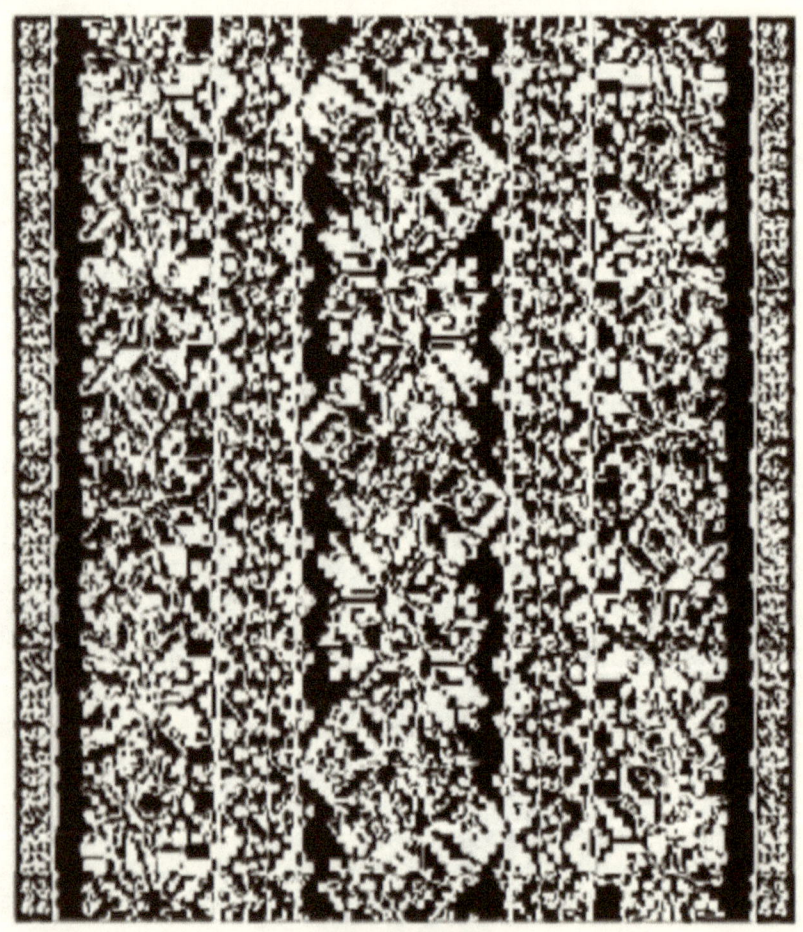

No.9

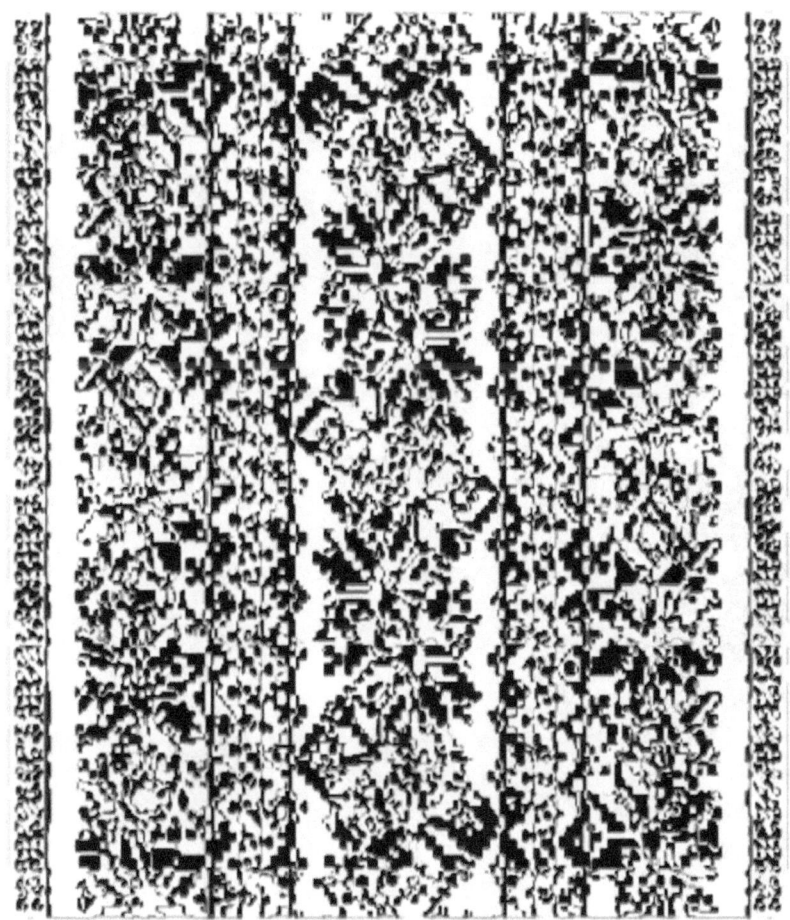

No.10

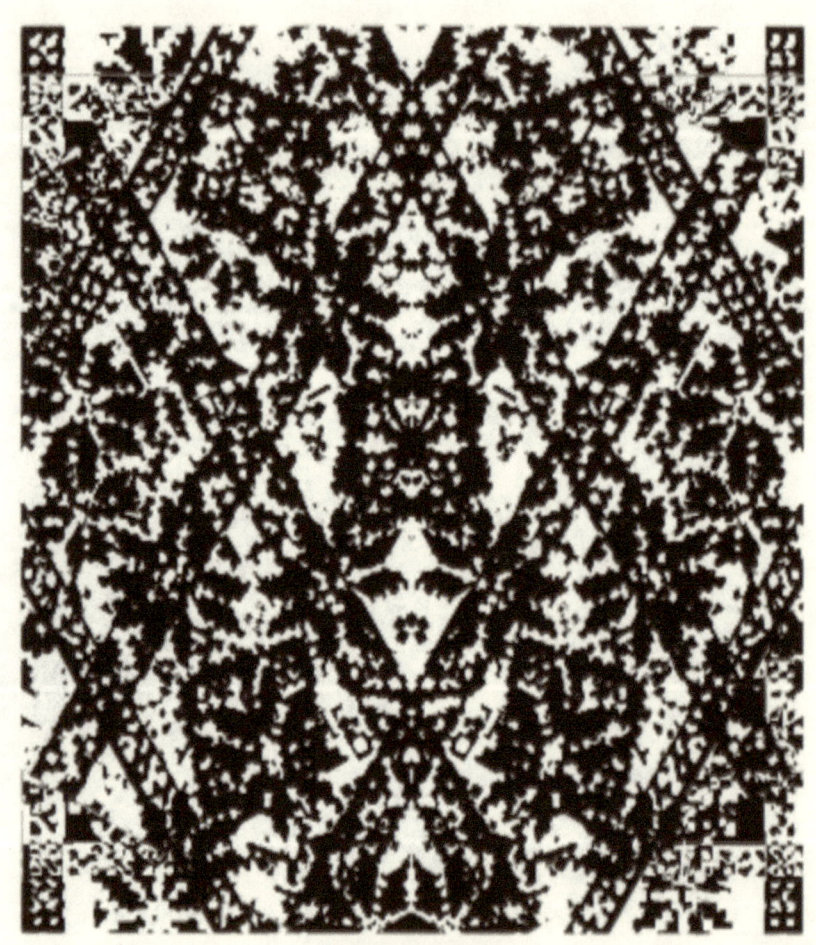

No.11

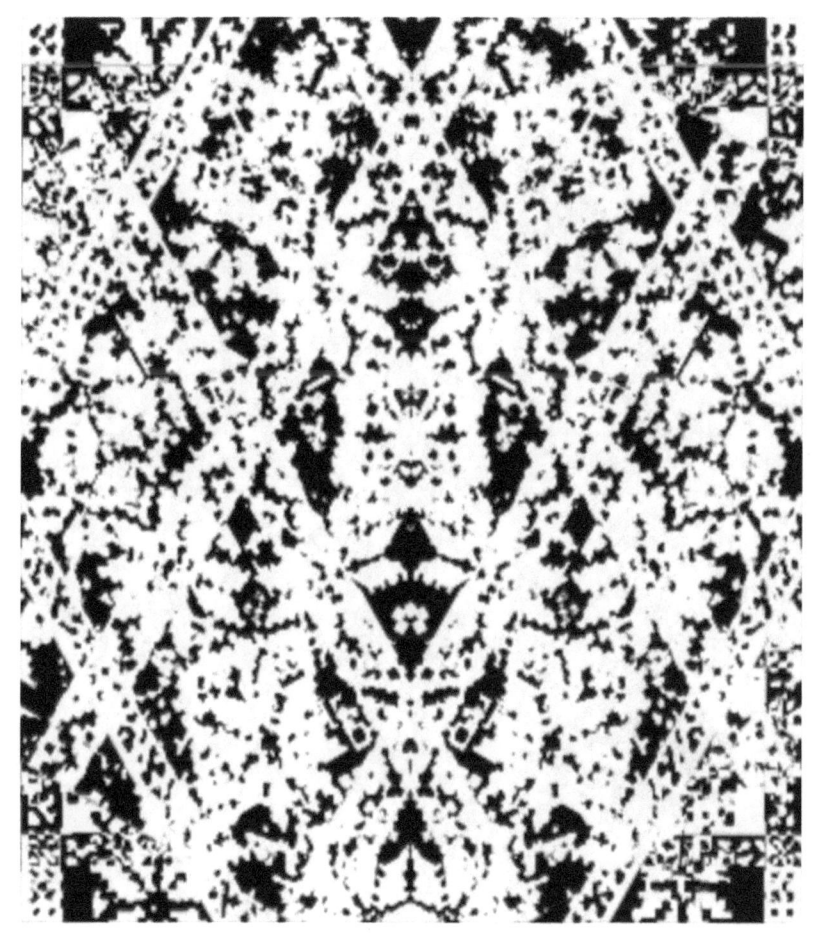

No.12

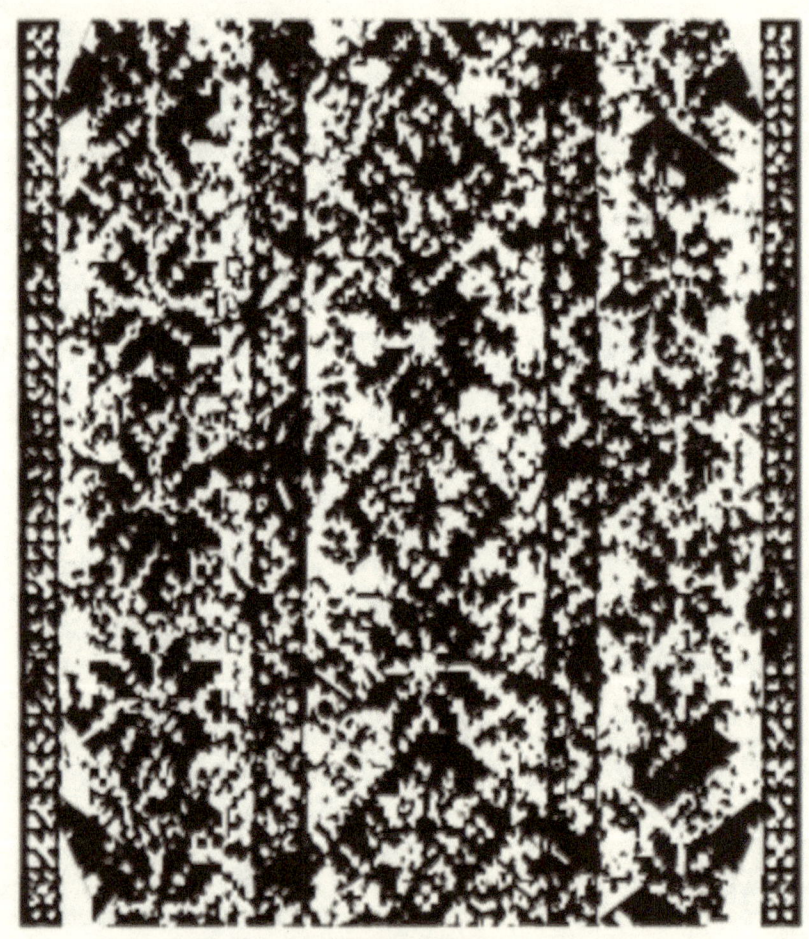

No.13

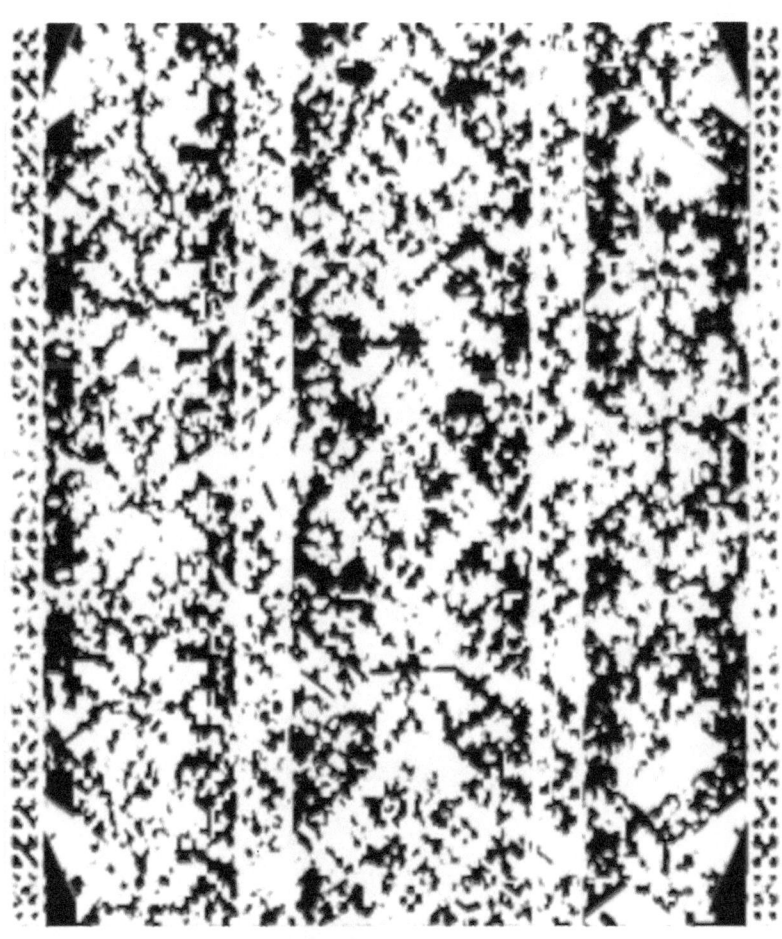

No.14

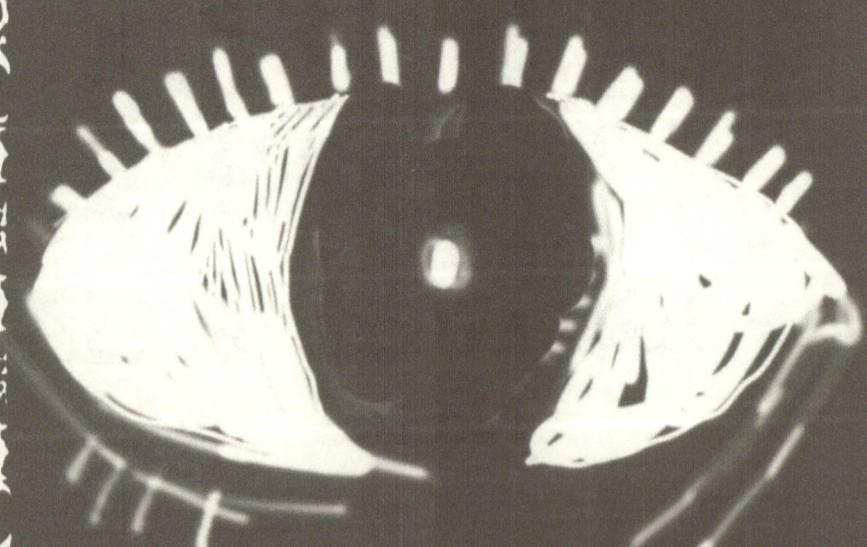

WHY PROCREATING LEADS TO UNAVOIDABLE HARM

by Chico

INTRODUCTION

"Is procreating, when the result is a being whose life is just barely worth living, a morally good action if the only alternative is not procreating?"

In this essay I will try to show a solution that, albeit unintuitive and radical, solves some of the problems originated by the more widely accepted answers to the problem. I will focus on the question from a different numbers choice inside the non- identity problem frame and, using the negative utilitarianism concept that suffering and well-being are lexically different, try to argue that no life is worth living and that procreating is neither morally required nor permissible.

NON-IDENTITY PROBLEM

First defined by Parfit the basic idea is the precariousness of existence. A small change in our conception conditions would mean that we, as an individual, would not have existed as we do now. He personally states it as: "If any particular person had not been conceived when he was in fact conceived, it is in fact true that he would have never existed" (Parfit, 1984, p. 421). This power that we have upon the future people originates the need for moral discussion.

Parfit separates the moral dilemma in three distinct cases inside the non-identity problem: Same people choices, when our decisions only affect their level of well- being; same numbers choices, when our actions decide who will exist; and different number choices, when the number of people will change (Parfit, 1984, p. 427). This last case will be the focus of my essay, since it describes accurately the question. By deciding whether to procreate, we are changing the number of people that will exist.

PERSON BASED SOLUTION

"An action is bad if it harms someone." is the view that leads to an unintuitive conclusion. There is no problem in bringing to life a child that will live a horrible life; we are not causing them any harm since had we not brought them to life, there would be no child at all. This view, however, only leads to this conclusion if we take into account a comparative harm account (Parfit, 1984, p. 447); something is harmful if not taking the action would cause less harm.

With the non-comparative account of harm (Shriffin, 1999, p. 123) however, something can be harmful on its own. One scenario that is often used to illustrate this idea is that if you are punched in the face, even if later the aggressor gives you money, you still have been harmed. The problem arises when we consider that if the person has still been made better off, is the harm morally bad?

UTILITARIAN BASED SOLUTION

One solution that does not involve a person-based account of morality is utilitarianism: an action is good if it maximizes well-being in general (Mulgan, 2014, chapter 2). What it leads to is balancing the well-being and suffering of all people as a whole; something can be wrong without being wrong to someone. Many forms of utilitarianism, however, lead to the repugnant conclusion: an enormous population will be morally better than a smaller one with higher individual levels of wellbeing, so we ought to maximize the number of people if that increases total well-being, ultimately leading to a very large, barely worth living in society (Parfit, 1984, p. 462).

ASYMMETRY

One other problem that appears to arise from all the possible solutions to the non- identity problem is the asymmetry issue. It seems that bringing a baby that would have a life not worth living is an immoral action because it would make them worse off, while at the same time leaving a future happy baby out of existence is totally permissible, even if existence would be better than non-existence for them. Forcing conception would not be a desirable conclusion, however that does not solve this apparent logical incongruence (McMahan, 2009, p. 49).

NEGATIVE UTILITARIANISM

The final bit of established theory that is needed to develop my proposal is a concept from negative utilitarianism (Popper, 2013, p. 548). It differs from the other variations in that suffering and well-being (happiness) are considered lexically different. That is, they pertain to different categories. No amount of well-being can compensate any suffering, for insignificant that it may seem. To justify my assumption of this idea, imagine the following thought experiment:
In scenario A, a person P is offered a position at a company. The conditions are precarious and the salary is not adequate. However, P decides to take the job and exchange suffering (working under poor conditions) for well-being (money). Now imagine a similar case, B, where we have the same person P and the same job. However instead of consciously deciding to work, P is forced to do so, still receiving the same payment.
One could argue that scenario A is moral, even if despicable, due to P having made a choice. However, I believe no one would even consider defending scenario B since forced labour is almost always considered immoral. In both cases, well-being cannot compensate suffering but in the first one we appeal to the human right to free-will for moral validation. When free will does not come into play, there is no way to justify case B.

ANTI-NATALIST CONCLUSION

From all the theories that have been explained and the possible solutions to the non- identity problem, the following conclusion can be reached.

(1) Giving birth leads to living
(2) Living consists of well-being (e.g., pleasure, happiness) and suffering (e.g., death, fear of death, injuries)
(3) No amount of well-being can compensate any suffering
(4) An action is harmful to someone if it leads to suffering
(5) An action is morally wrong if it is harmful to someone
(Conclusion) Giving birth is morally wrong

At first this posture might seem absurd and nonsensical. However, each of the individual premises make sense. I will review the possible criticisms later; for now, let's see what positive aspects this solution to the non-identity problem has over its counterparts. First off, by not using an impersonal account of morality, it can avoid the repugnant conclusion.
Next, although it is a person-based solution, we do not run into the issue of considering if the harm is morally relevant since, from the way the premises are laid out, giving birth leads to both a comparative harm (existence is worse than non- existence) and a non-comparative harm as well (inducing suffering is wrong even if not compared to anything). This posture avoids the asymmetry problem as well; one should not conceive if the resulting life would have even a small bit of suffering, which contain practically all the possible lives. Therefore, there is no such thing as a happy life, avoiding the moral obligation to procreate in such cases.
Finally, this solution coincides well with the intuition that having children when their life would be bad is a morally wrong choice. However, and now entering the issues with the posture, it is very unintuitive in most situations, forbidding conception in most, if not all, cases. It also goes against the rights of the parents: the right to freedom includes, one might argue, the freedom to chose when and whether to procreate. However just like murder is not considered a right since it causes harm to someone else, procreating should be considered likewise. Regarding the unintuitiveness of the conclusion, many moral theories turn out not to be intuitive at all. However, this is I believe because of our pre-established conceptions.
Looking at the premises, (1) and (2) are obvious, and need no justification. (4) could be criticised in that is it really harmful if the alternative is non-existence? However even if we do not consider it a comparative harm, it is still a non-comparative harm, and it would be hard to defend that personal suffering is not morally relevant. Premise (5) can be argued against in the sense that an action can also be wrong if it harms no one, however it surely is harmful if it

does harm someone, and using premise (3) no amount of pleasure or happiness that the birth of someone causes would compensate their personal suffering.

The most controversial premise is clearly (3). Before discussing it, I must admit that it could be easily argued against, and because of that I made it an assumption. One possible argument is that killing one person to save one billion would be morally permissible, however some philosophers consider that although it would be a morally good action, the person would have to choose to be sacrificed (Mulgan, 2014, p. 97). A parallelism can be established between this case and giving birth, since the suffering of the baby would be compensated by the pleasure of their whole family, or maybe the world if their baby would, for example, cure cancer. However, this argument has two major flaws: first off, the baby cannot make a decision because it does not exist before the action, secondly there has to be a threshold before which the suffering is not compensated. Since suffering and well-being are so hard to quantify, this threshold is virtually impossible to define, leading to an apparently good idea that is incomplete.

In general, the argument as a whole does not fall into logical fallacies and most of the premises are either obvious or easily argued for. The only one that would not hold scrutiny is the third, but it is a claim used in other moral theories and I see no issue with assuming it as true, since it is also intuitive in some ways. A final problem that I have noticed is that this solution does not answer the question at all. Since we reach the conclusion that no life is worth living, we cannot answer the question for a "life barely worth living". I believe that in that case yes it would be morally permissible to give birth, but according to my proposed solution a life "worth living" would only exist in a world without suffering or death.

CONCLUSION

In conclusion, I have briefly explained the non-identity problem and some of the possible solutions to it, while also noticing the problem that they had. I then proceeded to expose a logical sequence that led to my own posture, a valid although non-desirable anti-natalist solution to different number choices, and discussed its strengths and weaknesses, noting that it solves some of the problems with previous solutions to the non-identity problem while creating new ones.

References
Mulgan, T., 2014. **Understanding utilitarianism.** Routledge.
McMahan, J., 2009. **Asymmetries in the morality of causing people to exist. In Harming future persons** (pp. 49-68). Springer, Dordrecht.
Parfit, D., 1984. **Reasons and persons.** OUP Oxford.
Popper, K.R., 2013. **The open society and its enemies.** Princeton University Press.
Shiffrin, S.V., 1999. **Wrongful life, procreative responsibility, and the significance of harm. Legal Theory**, 5(2), pp.117-148.

Additional bibliography
https://plato.stanford.edu/entries/nonidentity-problem/ (27-10-2021)

you take my arms and i
have no age
i have all the age
i am now in a cottage
with walls of fog and
windows of ice of silence
and when my ears go away
from the cottage and hear
the people talking
the silence ice of the
windows is no more
you were in the cottage
you often are
sometimes playing a banjo
or a theremin
and it's never really bright
in there, but i like it
there's a dome where we
make sounds and the roof
doesn't let ~~it~~ THEM go away
we sleep
you become duvet

i wouldn't mind stopping breathing
entangled in a big you duvet ~~come~~
my ears ~~go~~ back again, no more you duvet, no more banjo, no more rippled glass ceiling that is a jail for sound
the sound doesn't want to go away so it's not a jail
the sound wants to dance in the banjo membrane, in the little bones inside your head, hidden behind a ~~labrynth~~ LABYRINTH
my ears go back and you still have my arms
our earth clothes are amalgamating, clothes from dead people, now ours, later for the worms
worms that live below the cottage with the glass sound jail

Magr

Casa

MY FEELINGS AND I IF WE WERE A HOME. (Part 1)

LUR MITXELENA / UNFISHEDFISH

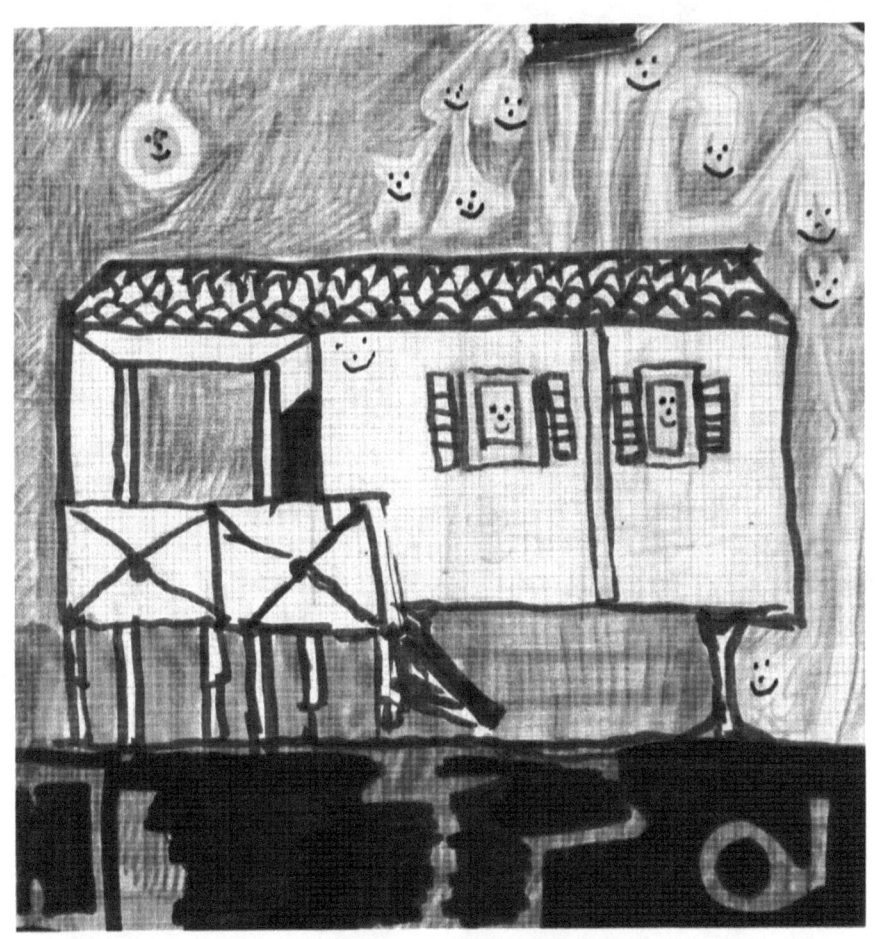

AND I REALIZED THAT I HAD BEEN LIVING MY WHOLE LIFE WITH ONE EYE CLOSED.

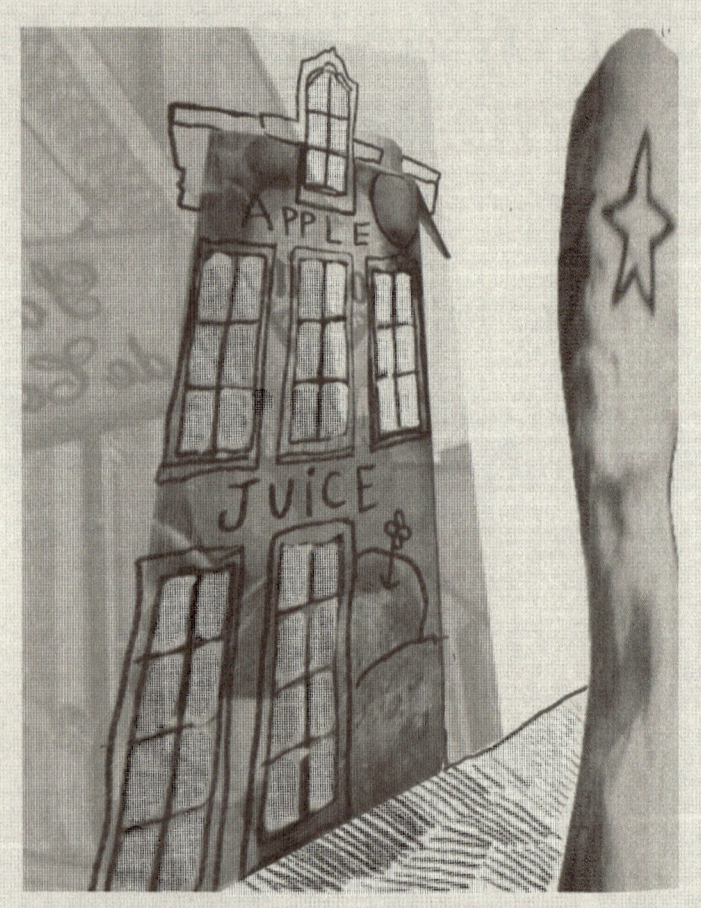

10. WEEPING FOR APPLES

siento que mis fuerzas se están conservando en un zumo de manzana.

06. SEASONS OF THE YEAR AND HAPPY PICKLES.

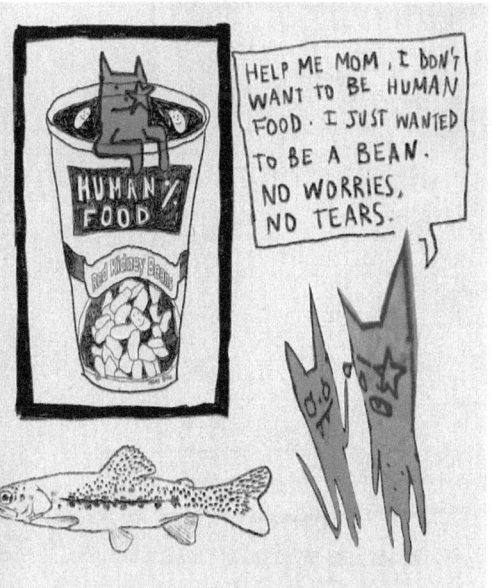

NO MORE SUGAR SWEETIE

Clasificar muchos tarros de comida y asignarlos por estaciones del año. A pesar de que se clasifiquen por estaciones poderlos tener todos al alcance. Que pueda ver lentejas y legumbres en un día de verano.

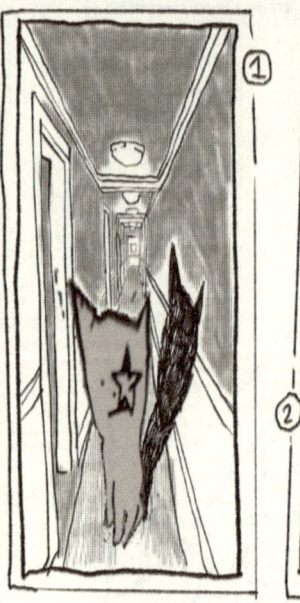 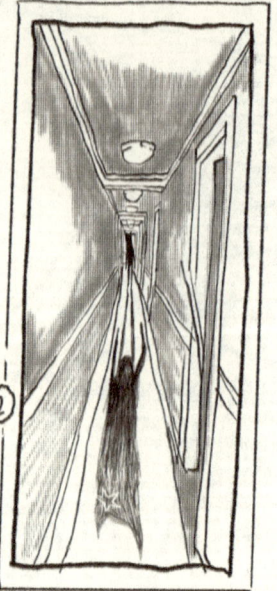

Un lugar con mucho silencio donde hay habitaciones co absolutamente nada. O u limón, a veces cuando n quiero pensar en nada se m impregna en la cabeza l imagen de un simple limón muy jugoso por su color muy grande por su textura Puede que sea un element muy reconfortante para mi todo lo contrario. No quier cuestionarmelo.

2. GOODBYE SHADE

02. CAT AND LEMON

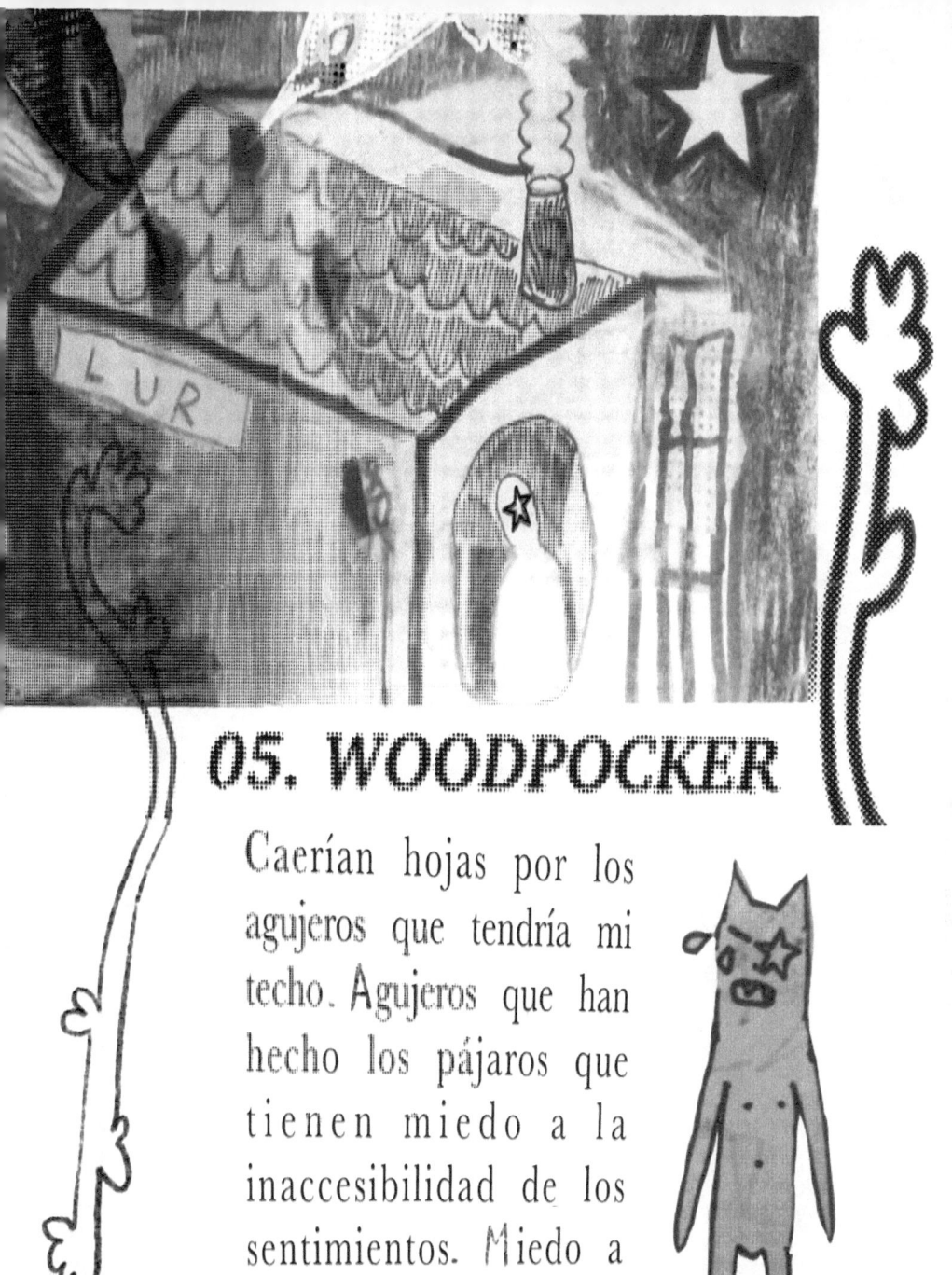

05. WOODPOCKER

Caerían hojas por los agujeros que tendría mi techo. Agujeros que han hecho los pájaros que tienen miedo a la inaccesibilidad de los sentimientos. Miedo a como poder llevarlos sin necesidad de romper el tejado.

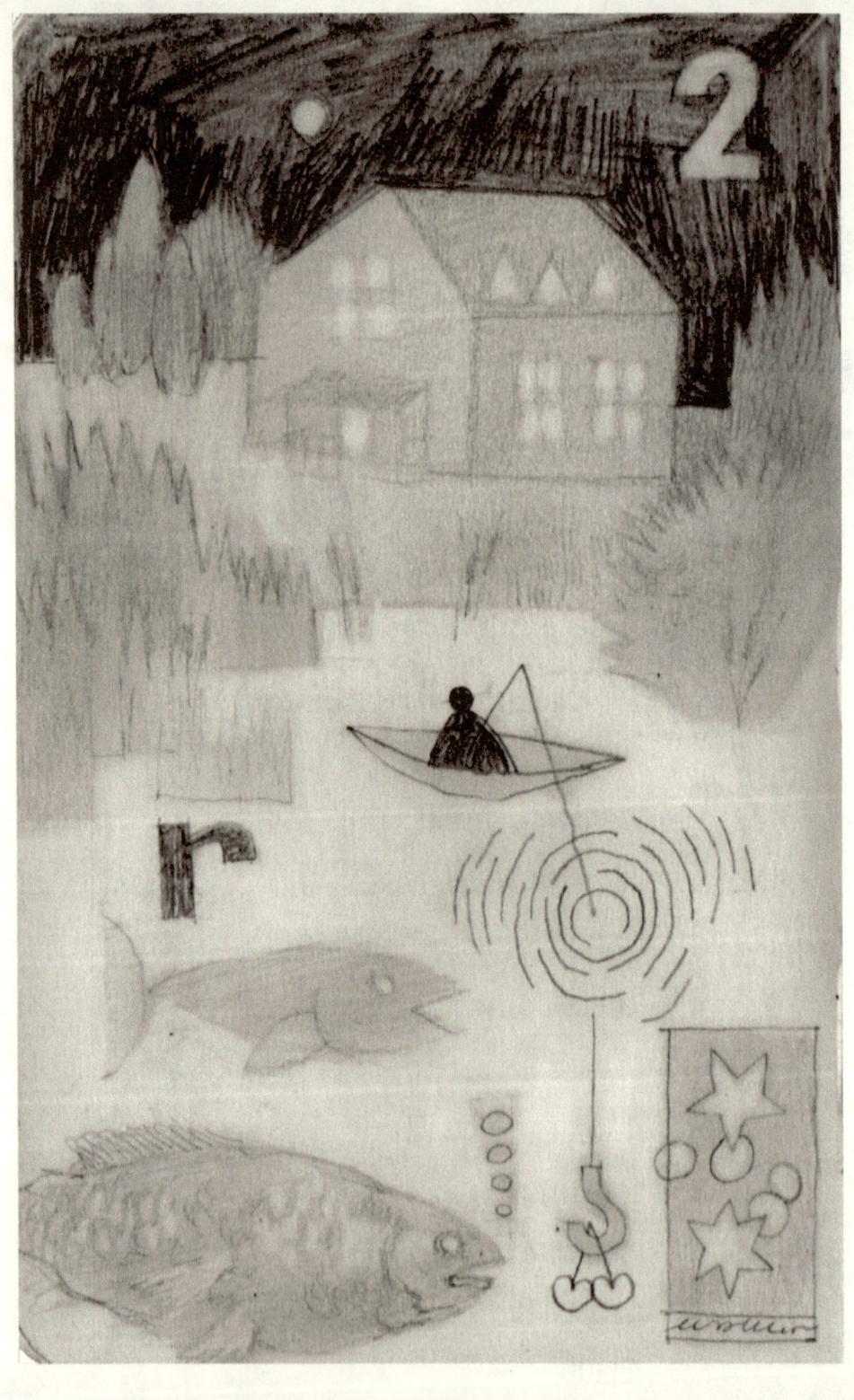

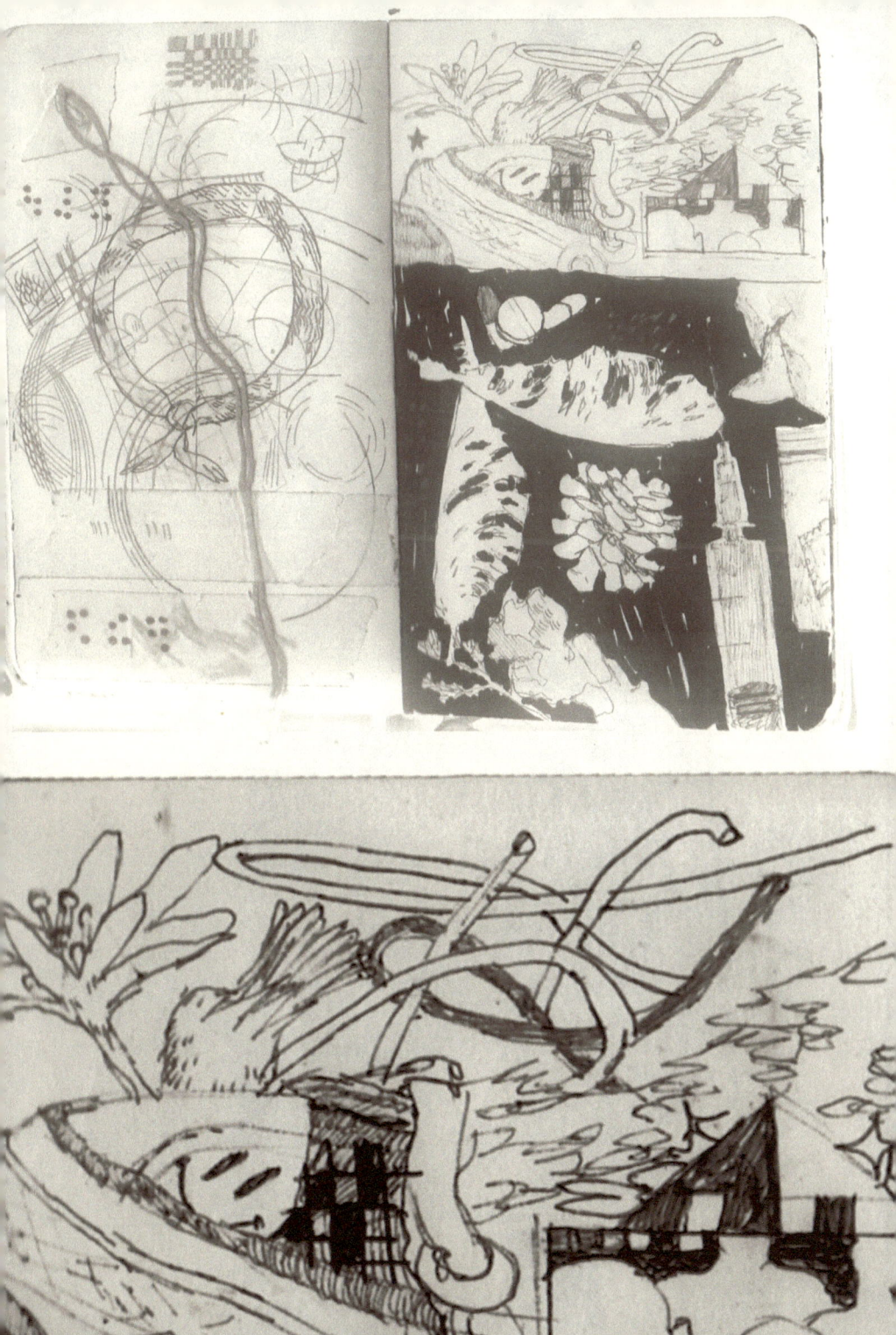

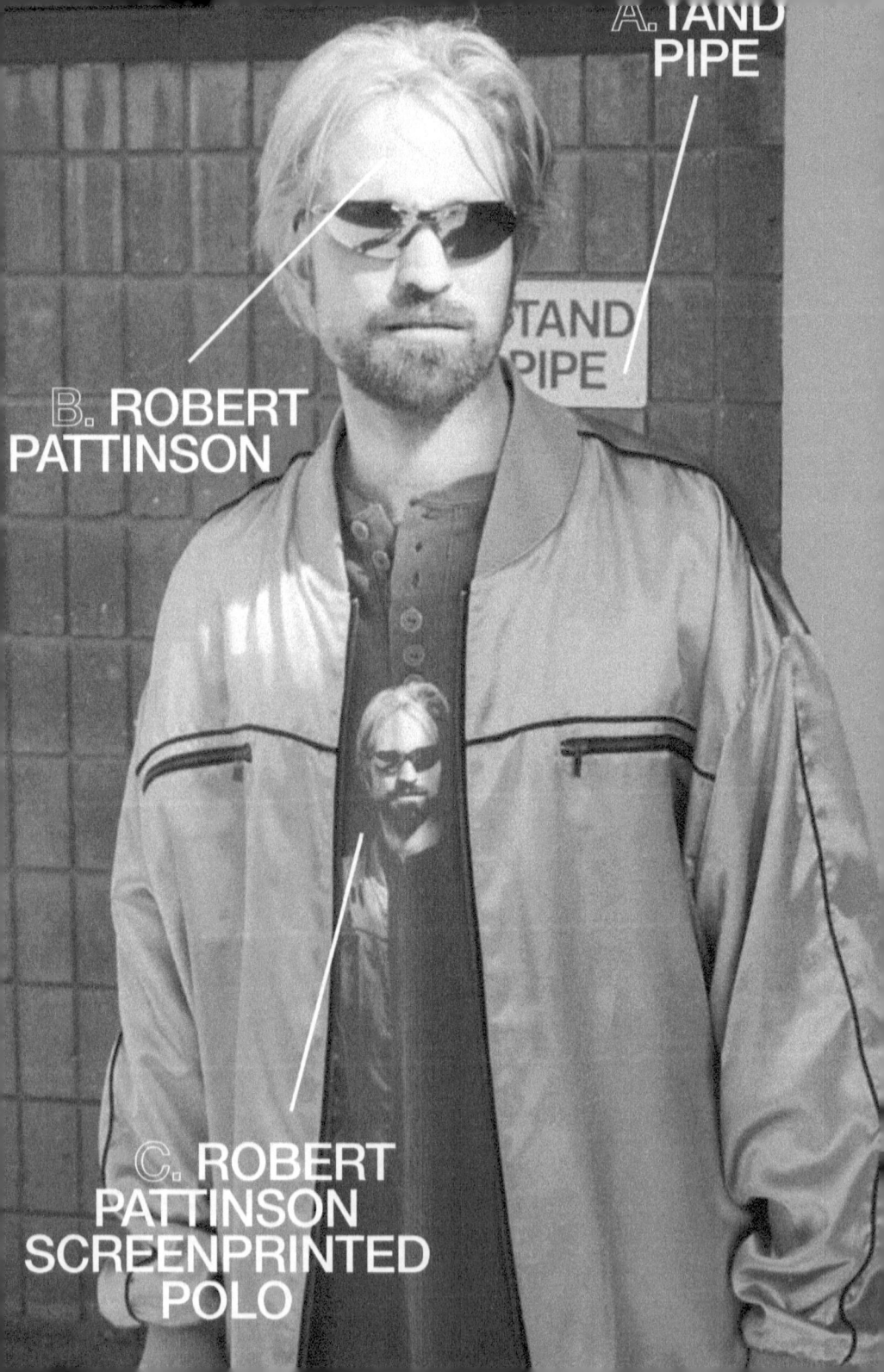

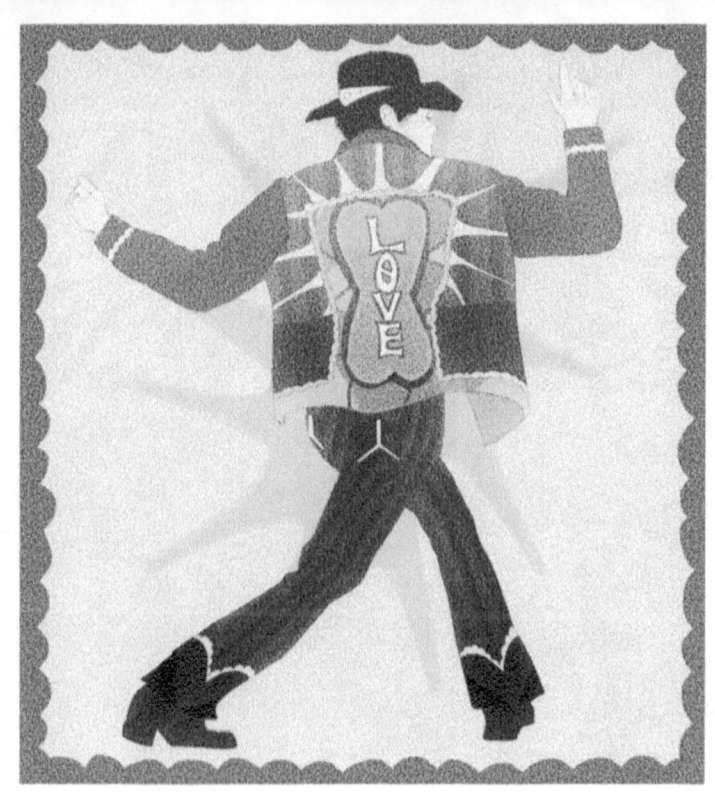
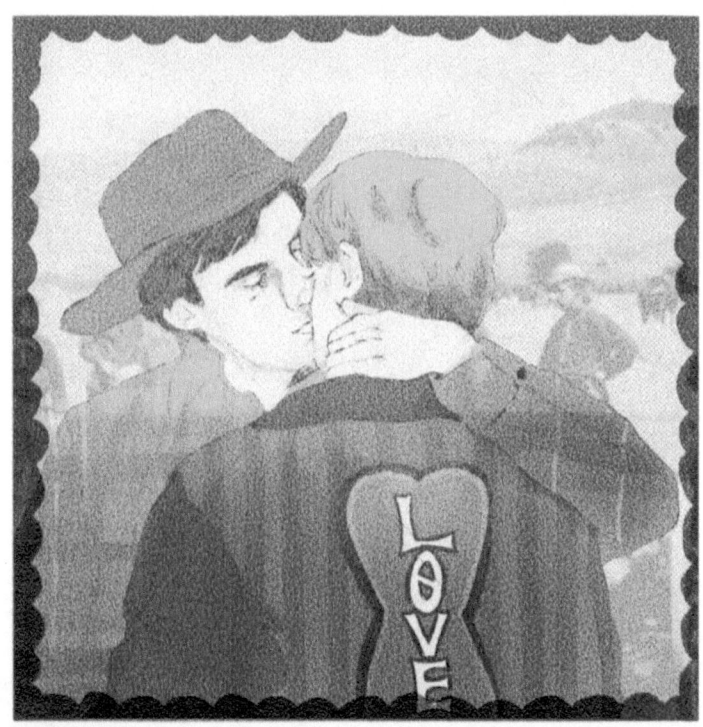

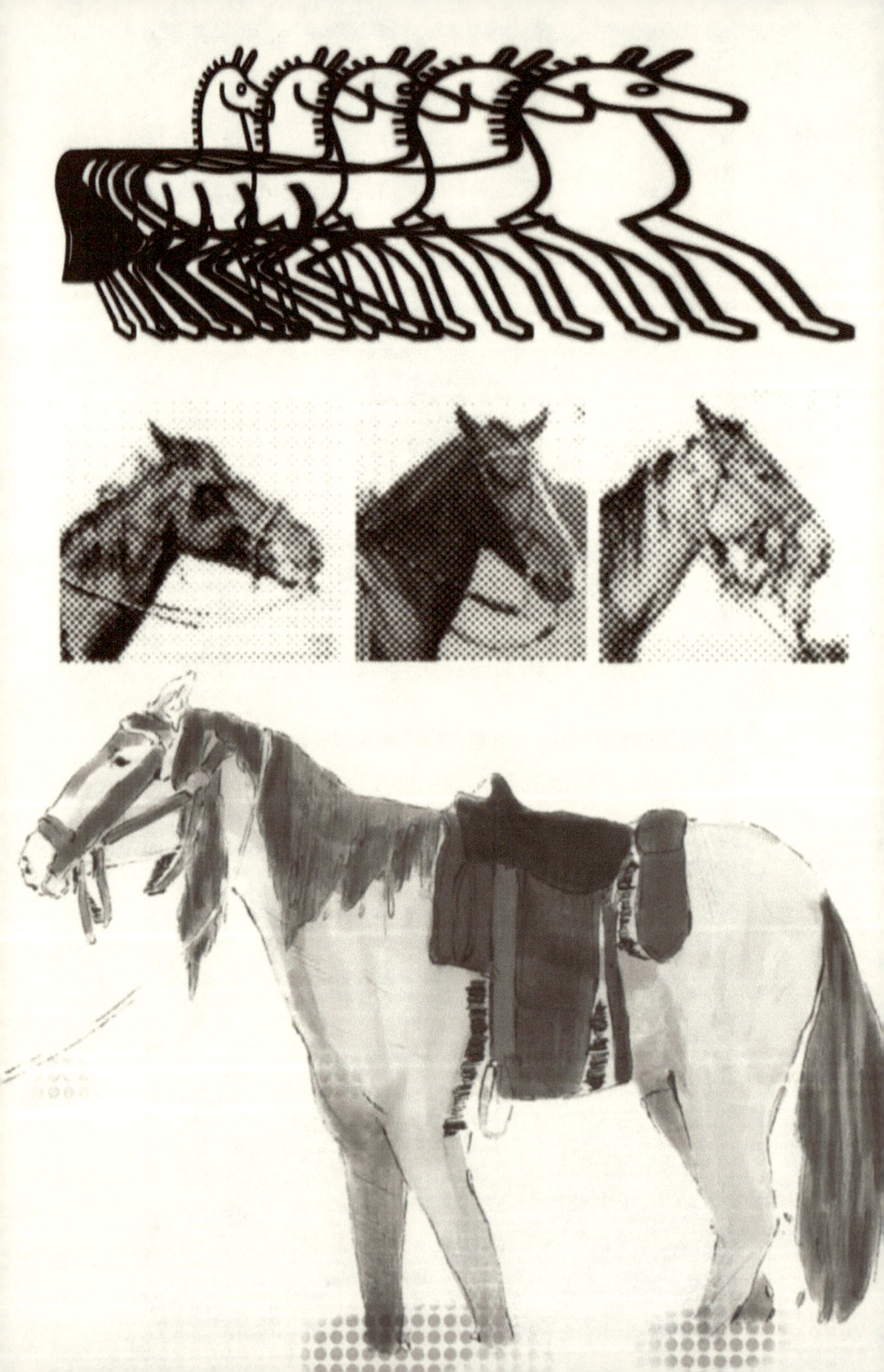

Synthesizing Brazilian Indigenous Patterns
IN THE STYLE OF HOKUSAI'S MANGA

no.1: Xingu

Jaburu Kamayurá I
Yawapi Kamayurá
(Xingu)

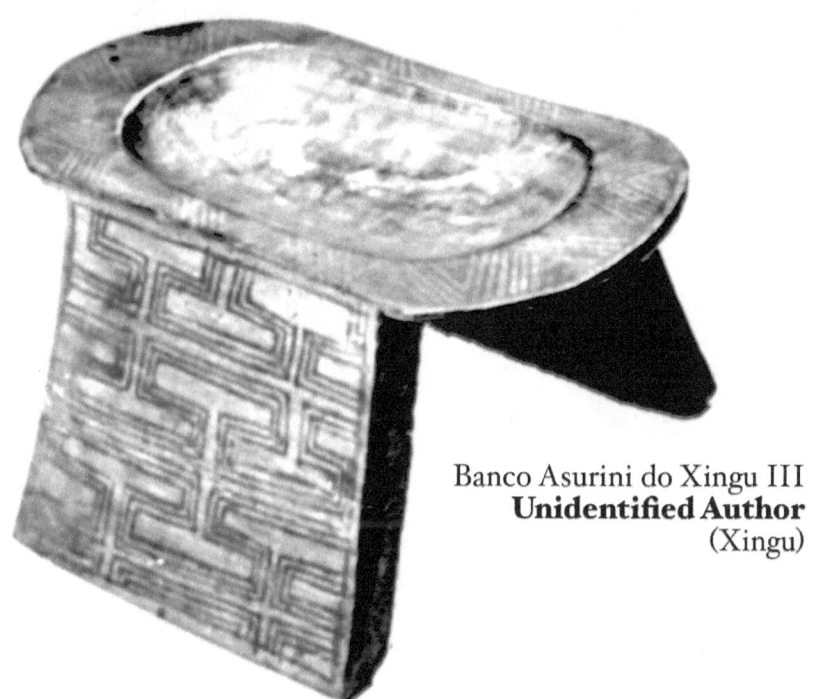

Banco Asurini do Xingu III
Unidentified Author
(Xingu)

Onça Yudjá V
Unidentified Author
(Xingu)

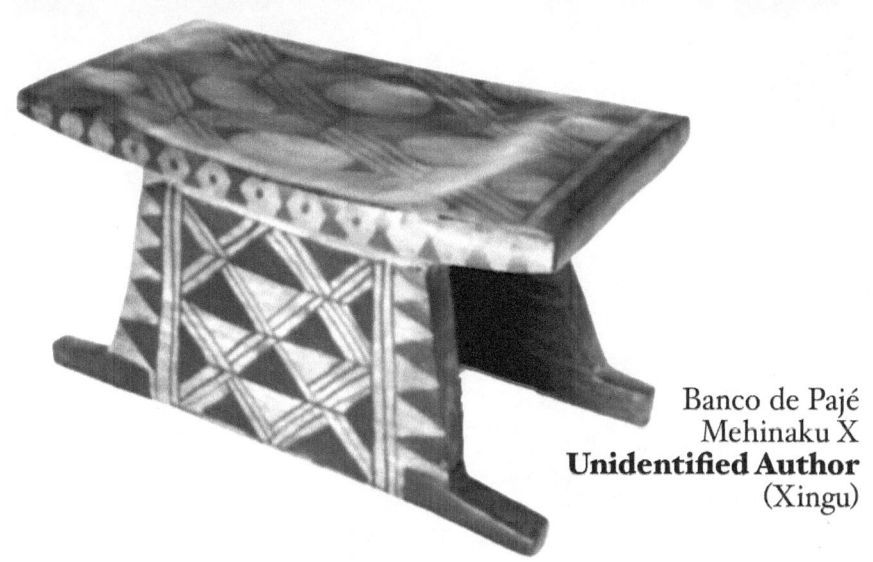

Banco de Pajé
Mehinaku X
Unidentified Author
(Xingu)

Banco
Zoomórfico
de Tamanduá
Unidentified Author
(Xingu)

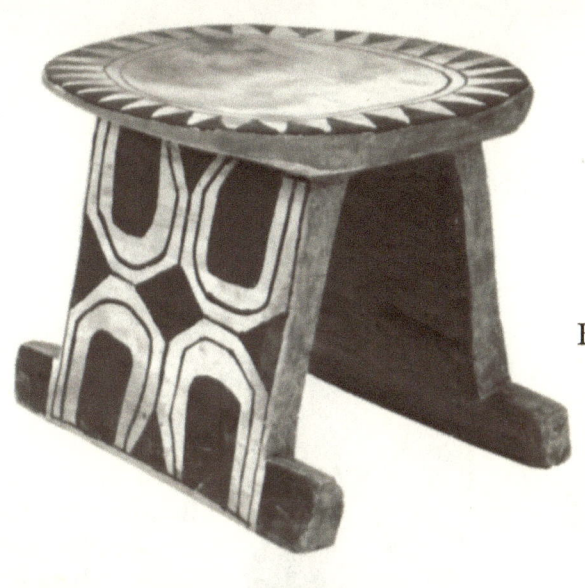

Banco de Pajé
Mehinaku V
**Kulikyrda
Mehinaku**
(Xingu)

Tamanduá-
Bandeira Kayabi
**Ropkranse
Kayabi**
(Xingu)

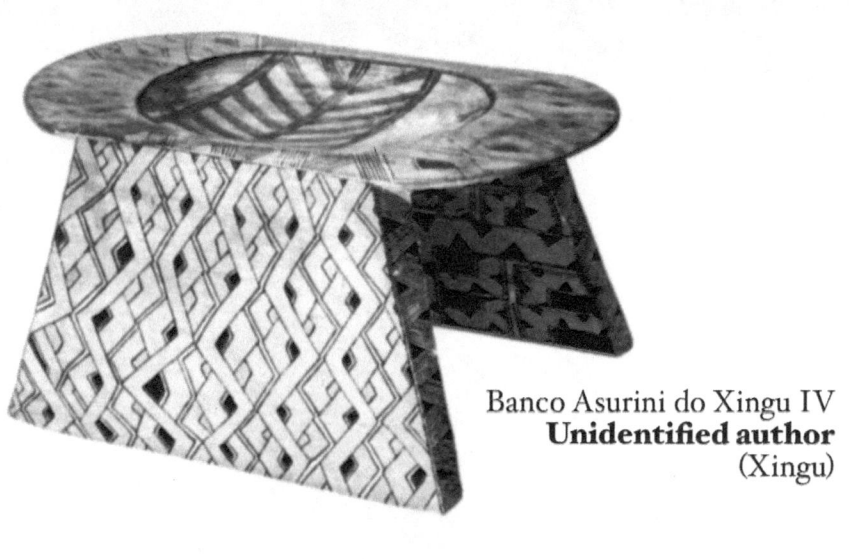

Banco Asurini do Xingu IV
Unidentified author
(Xingu)

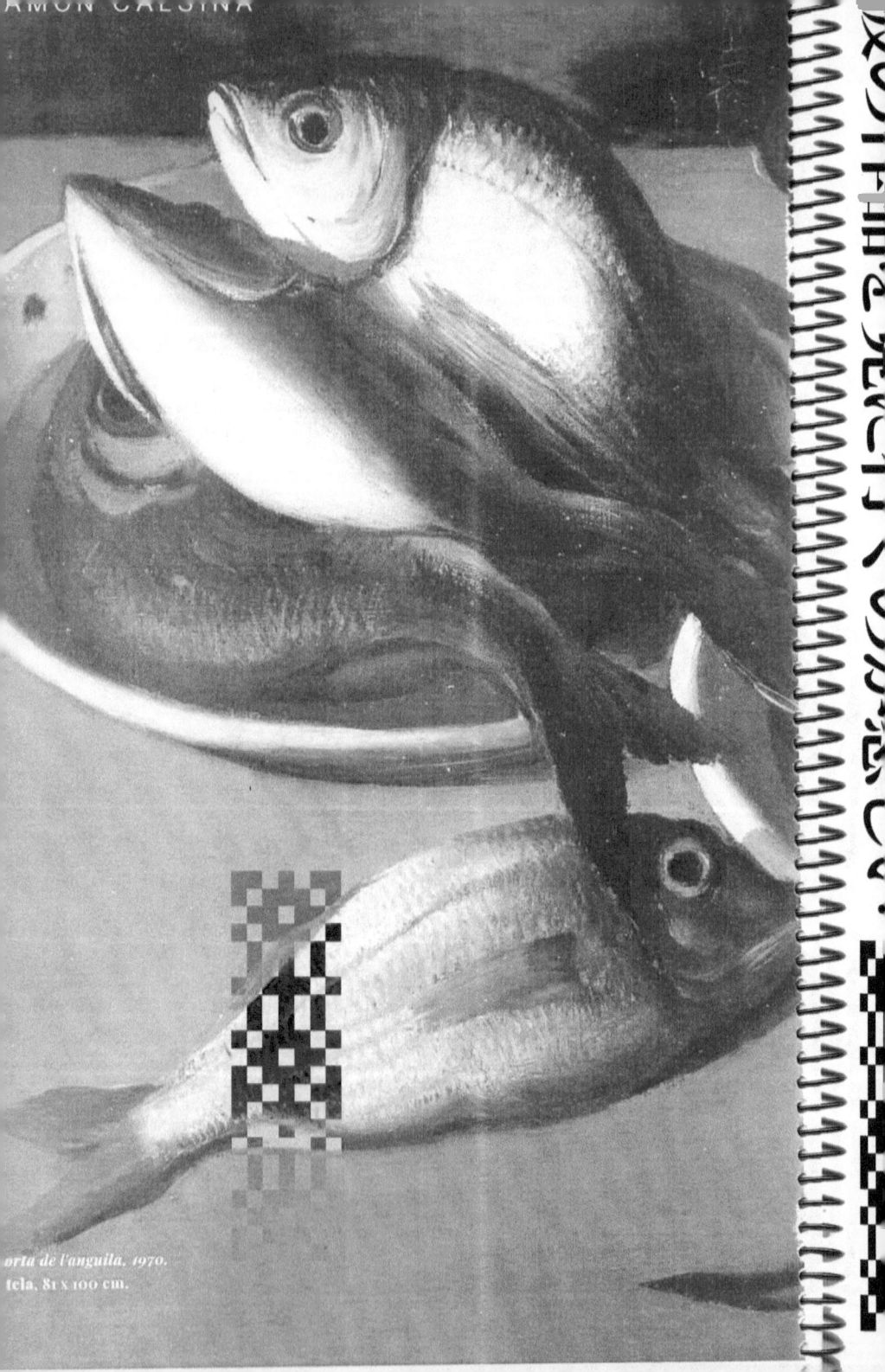

orta de l'anguila, 1970.
tela, 81 x 100 cm.

01.05.2022

0:10

song of the garden
a grey fetus of light
grey light, not dimmed white light
ofuscated guitar and digital cicadas humming
the two voices
the bald neighbour says goodbye,
with his blanket of embroided roses
i see the red lights of the back of his car
reflection on the quicksilvery mirror
of a pond on the frontyard
disturbed by waves of solar whispers

seas of weaved wool
laying on your chest, on the floor
as we listen to the voice
of the girl with the white hair
through the loudspeakers

MOTLEY

MOTLEY MAG
WILL HAVE A
SECOND
VOLUME

www.ingramcontent.com/pod-product-compliance
Lightning Source LLC
Chambersburg PA
CBHW020925180526
45163CB00007B/2882